JAMIE SHOVLIN

A DREAM DEFERRED

To Lille

JAMIE SHOVLIN
A DREAM DEFERRED

Haunch of Venison, London
6 July – 18 August 2007

THE OUTER LIMITS OF SOFTCORE

HOW A PARADISE WAS LOST ON THE FRONTIERS OF COUNTRY ROCK

Michael Bracewell

'In homeroom I sat at my desk and wrote over and over on my pale blue binder the words GOD IS NOWHERE / GOD IS NOW HERE / GOD IS NOWHERE / GOD IS NOW HERE. When this binder with these words was found, caked in my evaporating blood, people made a big fuss about it, and when my body is shortly lowered down into the planet, these same words will be felt-penned all over the surface of my white coffin. But all I was doing was trying to clear out my head and think of nothing, to generate enough silence to make time stand still.'

Douglas Coupland, *Hey Nostradamus!,* 2003.

Playmates and peaceniks; protest and murder; family photographs and high school yearbooks; the etiquette of good citizenship. Such is the centrifugal momentum of the modern American experience – or, rather, the remembered momentum of an era so close as to merge with our own, generation to generation. What began with modern novelty ends with guns and anaesthesia; transparent files of connected stories, caught in shafts of amber coloured light; the long low chord of an endless sunset.

You could date the modern history of pop and rock music, and all of its attendant cultural impact, from the moment when Elvis Presley's *Heartbreak Hotel* was first released in America by RCA records in January 1956. A little over twenty years later, in the late winter of 1977, another iconic US singles release, *Hotel California,* by the Eagles, seemed to mirror point for point the ghostly conceit which had lent such high octane glamour to Presley's first hit.

Both tracks – *Heartbreak Hotel* and *Hotel California* – were concerned with spiritual darkness, alienation and despair. One of Presley's most astute (if hostile) biographers, Albert Goldman, would write of the former in 1981:

'A caricature of the blues, a sequence of melodramatic vocal gesticulations, it isn't so much a song as a psychodrama … Rebellion and submission, exultation and despair, pride and humiliation – the important thing is the paradigmatic compression with which it delivers to the world that fascinating new character with whom everyone instantly identified Elvis: the down-in-the-gutter, ill-fated, nightmare-haunted punk hero.'

In this, the modern Pop age – an epoch in which mass production and mass media would channel, chill and commodify new notions of sexuality and celebrity – took as its starting whistle a declaration of suicidal isolation. To borrow from Goldman once more: '*Heartbreak Hotel's* grotesquely exaggerated and histrionic quality matched perfectly the hysterically self-pitying mood of millions of teenagers, who responded by making the record an instant and immense success.' History then records that by April 1956, *Heartbreak Hotel* had taken the Number One spot on all three American music charts – those for country and western, rhythm and blues and pop.

The lyric of *Heartbreak Hotel,* written by Mae Axton and Tommy Durden, was famously inspired by a headline that Durden had noticed on the front page of *The Miami Herald –* which he had picked up solely in order to read the racing page. Above a photograph of a corpse blared a question: 'Do you know this man?' – and the accompanying news story told of a suicide who had destroyed all the identifying marks on his clothing, and left only a single written line: 'I walk a lonely street'.

At the time, this was an unusual starting point for what was basically a mainstream

pop composition. Others – notably the great Johnnie Ray – had taken tears and melodrama as the basis for iconic pop performance, but *Heartbreak Hotel*, (which Mae Axton was determined would be Presley's first hit) brought to life an entirely different kind of darkness.

As Goldman rightly notes, the song and Presley's recording of it were the perfect aspirational template for hormonal teenage hysteria. But there is also a quality to the song that seems to articulate an ancient, sleepless neurasthenia within the heart of America's mythic identity. It is a quality which will re-surface time and again within American popular culture, articulating the Jungian sha-dow of the American dream – from Anthony Perkins' performance in *Psycho* (1960), to the presence of elemental evil that would be the subject of David Lynch's television drama series, *Twin Peaks* (1990–91).

In part descendant from the metaphors of post-lapsarian trauma with which American commentaries on the pioneer frontier had been encoded for two centuries prior to Mae Axton and Tommy Durden putting pen to paper, the Pop age reclamation of tragic fate would be as pronounced in *Hotel California* as it was in *Heartbreak Hotel*. With its drowsily calypso, seemingly feel-good guitar lines juxtaposed against a deceptively laid-back lyric, *Hotel California* was on first listening barely identifiable as a semi-ironical account of personal, national and spiritual dereliction.

Ubiquitous, on its release, to the point of inaudibility, this was a record which seemed to mark both the final act of American country rock in the 1970s, and simultaneously usher in the glossier, smoother, MOR rock sensi-bility of the 1980s. Certainly, it was a record that bridged the highly accelerated rise and fall of British and American post-punk and New Wave. There was a somehow dogged weariness to the twilit Americana that the track seemed to stand for – as though Presley's *Heartbreak Hotel* had been trans-formed into a nightmarish version of the preferred hotel of decadent rock superstars, the Chateau Marmont, in Los Angeles.

At the Hotel California, the values of bluesy, soft rocking authenticity which had reigned supreme during the imperial years of guitar-driven American rock during the 1970s, sud-denly curdle into a sickened and sickening confection. The 'pink champagne on ice', the 'pretty, pretty boys', the 'beast' that can't be killed and the assurance that guests might check in to the hotel but never leave – all update Presley's mourning black-clad desk clerk, and the bell-hop's flowing tears.

There is scant mysticism in *Hotel California*, nor even the comic book gothicism of *Heart-break Hotel*. Its seductive imitation of free-spirited Californian partying reveals anxiety and despair beneath the air-brushed, chrome-plated surface of soft rockist Americana. With covert malignancy, the song seems to assert that all which seemed most life-affirming about the American rockist dream

– the cowboy siesta of country rock – brings with it a shadow: part decadent, part mad, an agency of chaos, and terminal.

By the time the Steve Miller Band released *Industrial Military Complex Hex* in November 1970 – a pyschedelic protest blues song, its hook line taken from Eisenhower's valedictory speech as US president – something was most definitely rotten in the fall out of freak power. All that had seemed most promising through the rise of the American psychedelic era – a semi-organised celebration of new ideals and new liberations, carried on a formidable expansion of creativity within music and visual culture – had tripped on sudden deaths and ceremonial closures.

The drug related deaths of Brian Jones, Hendrix and Joplin were now joined by those of four student peace protesters shot by National Guardsmen at Kent State University; and as though to underline the end of an era, The Beatles finally split up. Dense layers of psychedelic and counter cultural activity had now given rise to a lowering sense of collapse and despair, its darkness deepened by the horrific murders (notably those carried out by followers of Charles Manson) which had now been carried out in the heart of the supposedly enlightened psychedelic community.

Interweaving narratives, simultaneously folk loric, heavy with conspiracy theory, myth,

and dedications to the enshrinement of new heroes, were matched by a more quotidian sense of a generation's spiritual deliquescence. If you looked to the community of freak power as a family, then the family had proved terminally dysfunctional, and all of the individual family units of which the greater tribe was formed were in danger of losing their reference points.

This sense of collapse, of the tipping of the freedoms of the late 1960s into the pop cultural hang-over of the early 1970s, would be marked in lyrics and recordings of historically poetic importance by the great singer songwriters Neil Young and Joni Mitchell – both Canadians, both concerned as writers with the relationship between hard realism and romantic ideals.

On Young's *After The Goldrush* (recorded with Steven Stills and Crazy Horse), no less than Joni Mitchell's *Blue* – the former released in 1970, the latter in 1971 – the sense is one of the Indian summer of psychedelia giving way to a sunless new world of hospitals and violence. 'Acid, booze and ass, needles, guns and grass – lots of laughs', sings Mitchell on the title track of *Blue*, adding: 'Everybody's saying that hell's the hippest way to go, well I don't think so.' For Young, the retreat from the mythic 'garden' of psychedelia and new freedoms is seen in a brutalist world of concrete and cars – 'Look at Mother Nature on the run in the 1970s.'

This was a requiem mood, alternately

plangent and yearning with melancholy, mourning the loss of grace which had once accompanied a generation's belief in all that was stardust and golden – Mitchell's 'billion year old carbon.' As free love reverted to lumpen sexual aggression and the short circuiting of identity politics, so too did the soft metaphors of happy family life begin to give way to new harshness. To be the off-spring of despairing, self-misunderstanding love children, in a world where new brutalities were configured with the reprise of old hatreds and immoveable power structures, was to inhabit a vivid new modernity: the exchange of the garden for the mall, of inner consciousness for outward looking mistrust, for psychedelic recla-mations of art nouveau for straight lines, of soft for hard.

This transition would be described by the great analyst (again Canadian) of post modern north American society, the novelist Douglas Coupland, in his second novel *Shampoo Planet*, published in 1992. It is the central character's hippy earth mother, Jasmine, who cuts through the chilled out irony of her slacker son with some advice about age: 'Life at that point will become like throwing a Frisbee in a graveyard; much of the pleasure of your dealings with your friends will stem from the contrast between your sparkling youth and the ink you know now lies at your feet.'

For Jasmine's son, a child brought up on a hippy commune, the 'ink' of his parents'

generation has formed the earliest mem-ories of his own. In a bravura passage, Coupland's character recounts:

'I remember robes made of flags, pots of stew and candles made of beeswax. I remember adults spending hours staring at the small skittering rainbow refractions cast from a window prism. I remember peace and light and flowers.

'But let me also tell you of when the world went wrong, of hairy faces violet with rage and accusation, of sudden disappearances, of lunches that never got made, of sweetpeas gone dead on the vine, of once meek women with pursed-lips and bulging forehead veins ... of lawyers visiting from Vancouver – the mood of collapse, of disintegration ...'

Coupland concludes his account of the last gloaming of flower power softness with a ride through the darkness to an edge tract of housing which comprises a town called Lancaster: 'Let me tell you of the house that became our new home and the new won-ders inside: switches, lights, grills, immediacy, shocks and crispness. I remember jumping up and down on the novel smooth floor and yelling, "Hardness! Hardness!"'

What might be the soundtrack to this new era of American, young middle aged dom-esticity? One answer to this would lie in the rise, from the mid 1970s onwards, of a form of heartlands rock – a fusion of rock, country

rock, and rhythm and blues, typified by Foreigner, Hall & Oates, Bob Seger and The Silver Bullet Band, Chicago and the Eagles. These were the house bands of a new American Pleasantville: an easy going, lazily rocking, folk-blues-feel-good musical alloy; a genre that would peak and implode with the monolithic popularity of *Hotel California* – the title track of which somehow came to be its own tombstone and epitaph.

This was a sound which seemed to stretch away, endless, like the streetlighting grids of the modern suburbia. It seemed to speak of shopping malls and barbecues, of modest bars and family parties; it was a musical form which seemed to convert the epic into the domestic, and vice versa. One could tag it the music of occlusion; the accompaniment to a dream deferred.

For a body of work so steeped in the sharp, heady brew of modern American cultural history, there is a tracery of defiant Englishness within Jamie Shovlin's mesmeric extrapolation of folkloric soft rock, *A Dream Deferred*. It is a trait which has the resonance of a high minor chord, and, like all minor chords it speaks above all of melancholy. Its temper was best defined, perhaps, by Philip Larkin (one of the most English of English poets) in his poem *Home Is So Sad:* 'A joyous shot at how things ought to be, long fallen wide.'

Written in 1958 – twenty years before Jamie Shovlin was born – *Home Is So Sad* describes the emotional residue that accumulates in family homes, and which later becomes so eloquent in their ornaments and furnishings. It is the fate of such gentle, quotidian muniments, Larkin suggests, to become the agents of a profound sense of loss. If their purpose was once to endorse the life affirming values proposed in the very notion of home, then their destiny can often be to signify the opposite: a statement of gradual yet somehow inevitable failure, underlined with the alternately keen and dulled sense of resignation that is so particular to the experience of abandonment.

These are themes which are transposed, within the premise of *A Dream Deferred,* from the locality of British domesticity, by way of iconic Modernism and a record collection some three decades old, to both the epic sweep of recent American history and to the mythic, pioneer lands of emotional epiphany once hymned in the soft rock Americana of the middle to late years of the 1970s. What emerges from this transposition is a meditation on the nature of time and age, of compromise and violence, and the fragile volatility of once deeply romantic and assured ideals. You might call it a dark metaphysics of Modernism, neglected but sleepless within the largely unvisited shadowlands of country rock – a keening sorrow on the outer limits of softcore.

GROUND

FLOOR

1

THE COURSE OF EMPIRE

2007
Acrylic on canvas
183 x 183 cm

The Course of Empire depicts the cover of America's album *Harbor* (1977).[1] The painting has been realised in acrylic using an airbrush, lending the scene a kitsch appearance. Both this and the manner in which the album title seemingly hovers above the landscape recall Ed Ruscha's paintings featuring landscape and text.[2]

The idyllic imagery is reminiscent of the Hudson River School of painting and the title references an iconic series of paintings by Thomas Cole (1801–1848).[3] *The Course of Empire* (1834–36), now in the New York Historical Society, is a five-part series depicting the growth and fall of an imaginary city and is notable in part for reflecting popular American sentiments of the times, when many saw pastoralism as the ideal state of humanity, while fearing that the growth of empire would lead to excess and inevitable decay. Such concerns can be seen as mirroring a sense of malaise, of good times gone bad, that many commentators saw in American society in the aftermath of the 1960s.

1. *Harbor* was the seventh studio album by American folk-rock trio America, and was recorded in Hawaii; the cover imagery is actually a Hawaiian coastal scene. Despite its presence in the Shovlin family record collection it was a commercial failure, especially after early successes such as *America* (1971), which included 'A Horse with No Name', a worldwide hit in 1972, and *Homecoming* (1972).

2. See, for example, *America's Future* (1979) or *Barns and Farms* (1983).

3. The Hudson River School was a group of mid-nineteenth century American landscape painters, including Thomas Cole, Frederick Edwin Church and Albert Bierstadt. Many Hudson River School paintings reflect three key nineteenth century American concerns: discovery, exploration, and settlement. The paintings depict a pastoral American landscape where humans and nature coexist peacefully and are characterised by their realistic, detailed, and often idealised portrayal of nature. Many of the artists believed that nature in the form of the American landscape was an ineffable manifestation of the divine, though the artists varied in the depth of their religious conviction. Work by the Hudson River School was showcased in *The American Sublime* at Tate Britain, London in 2001.

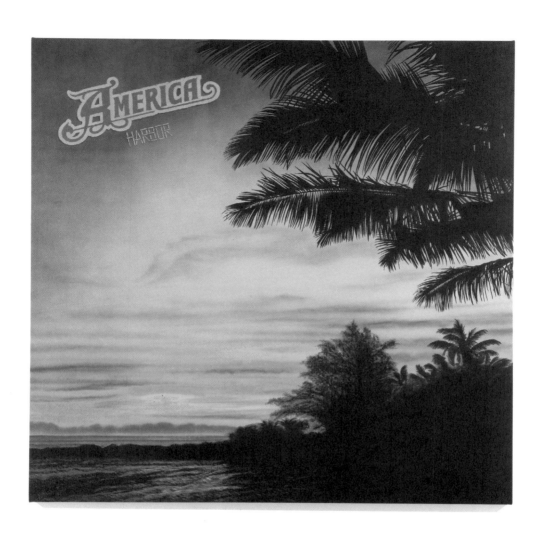

ARE YOU REELIN' IN THE YEARS...

2007
Cibachrome
31 x 25 cm

For *Are you reelin' in the years…*, Shovlin has re-photographed
an old family snapshot. Taken by an unknown photographer,
the original image depicts Valerie and Denis Shovlin with the
infant Jamie positioned between them, at a family wedding
some time in the late 1970s. Shovlin's act of re-photographing
not only suggests the retrieval of memory but also references
the strategies of artists such as Richard Prince and Sherrie
Levine.[4] Issues of appropriation, authorship (and ownership)
run throughout *A Dream Deferred*.

The title is taken from the lyrics of 'Reelin' in the Years', a
song by the American band Steely Dan, originally released
on the album, *Can't Buy a Thrill* (1972).

4. In 1977, Richard Prince created
controversy by re-photographing four
photographs which had previously
appeared in *The New York Times*.
This action provoked a major dis-
cussion in the art world concerning
authorship and authenticity. Sherrie
Levine is best known for *After Walker
Evans*, her 1981 solo exhibition at
Metro Pictures in New York. The
works consisted of famous Walker
Evans photographs, re-photographed
by Levine from an exhibition cat-
alogue, and then presented as
Levine's artwork with no further
manipulation of the images.

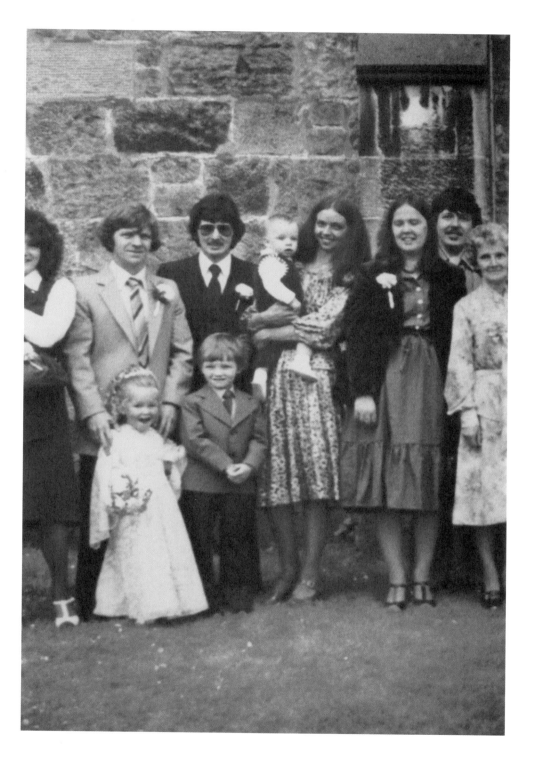

...ARE YOU STOWING AWAY THE TIME?

2007
Two DVDs looped through two monitors, two DVD players
Approximately 9 minutes each
Dimensions variable

The companion work to *Are you reelin' in the years...* (cat.2)
features edited interviews with Shovlin's parents separately
in their respective homes. They relate the circumstances of
their acquisition of the albums which have served as source
material for *A Dream Deferred*, and recall (and fail to
remember) what they liked and disliked about the records,
and what each record meant to them.

The interviews serve to prioritise the specific and the
subjective. With attendant lapses of memory, Valerie and
Denis's view of music history is entirely personal. Taken
together these two works announce a series of themes
that run through *A Dream Deferred*: families, the passage
of time, the failure of memory, the integration of personal
and public history.

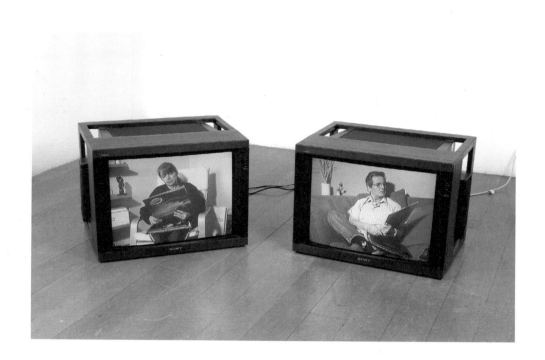

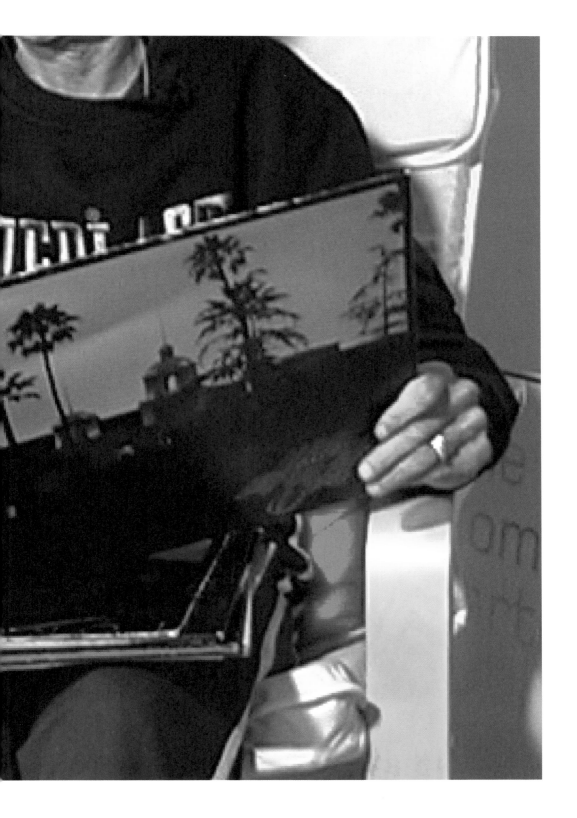

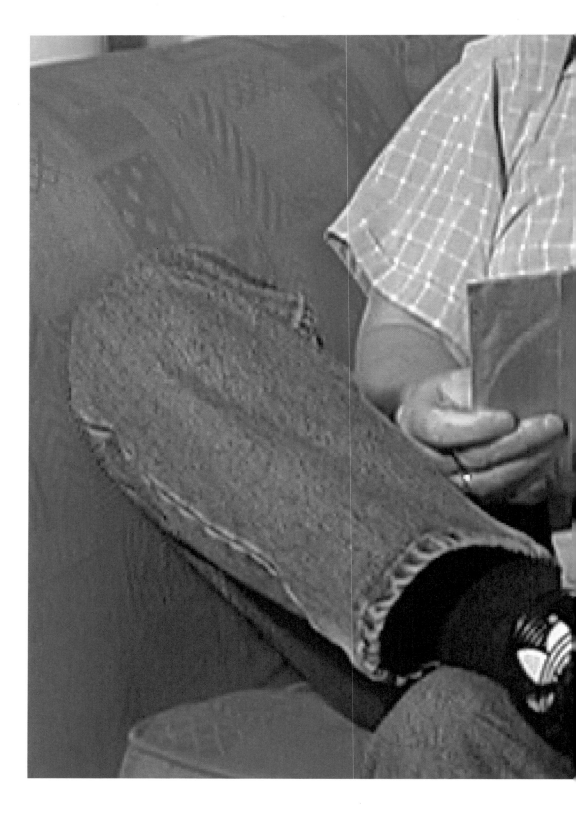

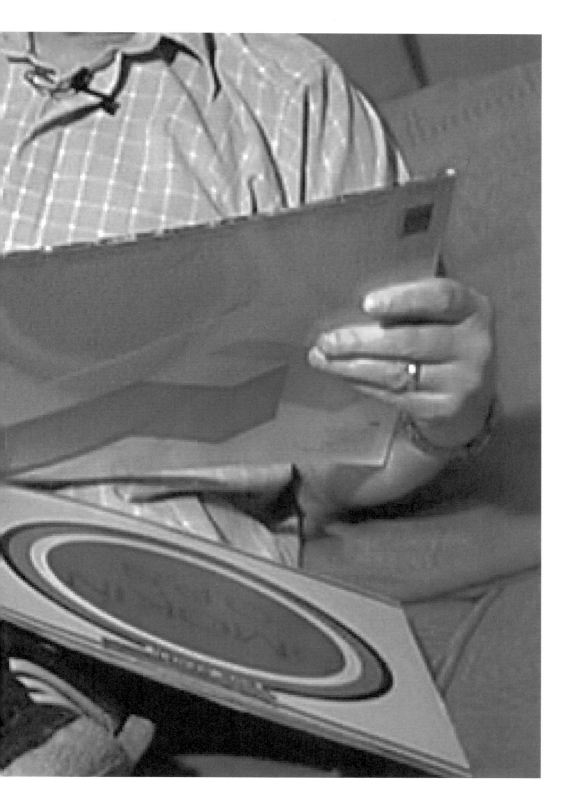

4

TBSD.JPG

2007
Pencil, graphite, and charcoal on paper
50 x 60 cm

Tbsd.jpg depicts a stamped plank left by Andrew Kehoe, the perpetrator of what has become known as the Bath School Disaster in 1927.[5] As the title (and mis-registered positioning of the image on the page) suggests, the image has been sourced and drawn directly from the internet. The sign was wired to a fence on Kehoe's farm and was discovered in the wake of the disaster.

The work serves to further one of the central thematic elements of the exhibition – the legacy of generational baggage – whilst also foregrounding the increasingly prevalent phenomenon of school violence in modern America.[6] Here, it is referenced rather obliquely through an obscure visual cast-off of an almost-forgotten crime.

5. On 18 May 1927 a series of bombs killed 45 people and injured 58 in Bath Township, Michigan. Most of the victims were children attending the Bath Consolidated School. The perpetrator was Andrew Kehoe, a member of the school board, who was upset by a property tax that had been levied to fund the construction of school buildings. He blamed the additional tax for financial hardships which led to foreclosure proceedings against his farm. Kehoe first killed his wife and then set his farm buildings on fire. He then set off explosives concealed within the north wing of the school building, killing many of the people inside. As rescuers started gathering at the school, Kehoe arrived and detonated a bomb inside his shrapnel-filled car, killing himself and killing and injuring several others.

6. The two most high profile incidents in recent years occured at Columbine High School and Virginia Tech. On 20 April 1999, at Columbine High School in Jefferson County, Colorado, two students, Eric Harris and Dylan Klebold, went on a shooting rampage, killing 12 students and a teacher, as well as wounding 24 others, before committing suicide. On 16 April 2007, on the Virginia Tech campus in Blacksburg, Virginia, Seung-Hui Cho killed 32 people and wounded many more before committing suicide, making it the deadliest shooting in modern US history.

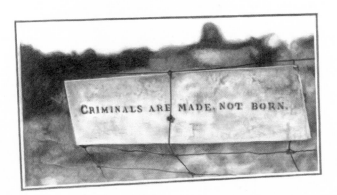

FIRST

FLOOR

IN SALUTATION OF ASHES

2007
Vinyl wall text
120 x 190 cm

In Salutation of Ashes details some of the official 'Flag Etiquette' relating to the American Stars and Stripes, specifically the list of what the flag user should *not* do with the flag and the correct method of disposing of a damaged flag (by cremation – a fact reflected in the choice of title).

The type is set in Franklin Gothic, a font commonly associated with Lawrence Weiner.[7] *In Salutation of Ashes* introduces ideas relating nationalism and adherence to codes which are further explored in the group of works alongside which it is exhibited (cats. 6, 7, 8, 9).

7. Weiner is regarded as a key figure within the development of Conceptual Art in the 1960s. His text works are dense, allusive and often intensely poetic. In 1969 Weiner asserted that 'I really believe the subject matter of my art is – art.' Quoted in Benjamin H. D. Buchloh et al., *Lawrence Weiner*, Phaidon, 1998, p.96.

RESPECT FOR THE FLAG

NO DISRESPECT SHOULD BE SHOWN TO THE FLAG OF THE UNITED STATES OF AMERICA; THE FLAG SHOULD NOT BE DIPPED TO ANY PERSON OR THING. REGIMENTAL COLORS, STATE FLAGS, AND ORGANIZATION OR INSTITUTIONAL FLAGS ARE TO BE DIPPED AS A MARK OF HONOR.

A) THE FLAG SHOULD NEVER BE DISPLAYED WITH THE UNION DOWN, EXCEPT AS A SIGNAL OF DIRE DISTRESS IN INSTANCES OF EXTREME DANGER TO LIFE OR PROPERTY.

B) THE FLAG SHOULD NEVER TOUCH ANYTHING BENEATH IT, SUCH AS THE GROUND, THE FLOOR, WATER, OR MERCHANDISE.

C) THE FLAG SHOULD NEVER BE CARRIED FLAT OR HORIZONTAL, BUT ALWAYS ALOFT AND FREE.

D) THE FLAG SHOULD NEVER BE USED AS WEARING APPAREL, BEDDING OR DRAPERY. IT SHOULD NEVER BE FESTOONED, DRAWN BACK, NOR UP, IN FOLDS, BUT ALLOWED TO FALL FREE. BUNTING OF BLUE, WHITE, AND RED, ALWAYS ARRANGED WITH THE BLUE ABOVE, THE WHITE IN THE MIDDLE, AND THE RED BELOW, SHOULD BE USED FOR COVERING A SPEAKER'S DESK, DRAPING IN FRONT OF THE PLATFORM, AND FOR DECORATION IN GENERAL.

E) THE FLAG SHOULD NEVER BE FASTENED, DISPLAYED, USED, OR STORED IN SUCH A MANNER AS TO PERMIT IT TO BE EASILY TORN, SOILED, OR DAMAGED IN ANY WAY.

F) THE FLAG SHOULD NEVER BE USED AS A COVERING FOR A CEILING.

G) THE FLAG SHOULD NEVER HAVE PLACED UPON IT, NOR ON ANY PART OF IT, NOR ATTACHED TO IT ANY MARK, INSIGNIA, LETTER, WORD, FIGURE, DESIGN, PICTURE, OR DRAWING OF ANY NATURE.

H) THE FLAG SHOULD NEVER BE USED AS A RECEPTACLE FOR RECEIVING, HOLDING, CARRYING, OR DELIVERING ANYTHING.

I) THE FLAG SHOULD NEVER BE USED FOR ADVERTISING PURPOSES IN ANY MANNER WHATSOEVER. IT SHOULD NOT BE EMBROIDERED ON SUCH ARTICLES AS CUSHIONS, HANDKERCHIEFS, AND THE LIKE, PRINTED OR OTHERWISE IMPRESSED UPON PAPER NAPKINS OR BOXES OR ANYTHING THAT IS DESTINED FOR TEMPORARY USE AND DISCARD. ADVERTISING SIGNS SHOULD NOT BE FASTENED TO A STAFF OR HALYARD FROM WHICH THE FLAG IS FLOWN.

J) NO PART OF THE FLAG SHOULD EVER BE USED AS A COSTUME OR ATHLETIC UNIFORM. HOWEVER, A FLAG PATCH MAY BE AFFIXED TO THE UNIFORM OF MILITARY PERSONNEL, FIREMEN, POLICEMEN, AND MEMBERS OF PATRIOTIC ORGANIZATIONS. THE FLAG REPRESENTS A LIVING COUNTRY AND IS ITSELF CONSIDERED A LIVING THING. THEREFORE, THE LAPEL PIN BEING A REPLICA, SHOULD BE WORN ON THE LEFT LAPEL NEAR THE HEART.

K) THE FLAG, WHEN IT IS IN SUCH CONDITION THAT IT IS NO LONGER A FITTING EMBLEM FOR DISPLAY, SHOULD BE DESTROYED IN A DIGNIFIED WAY, PREFERABLY BY BURNING.

BE DISPLAYED WITH THE UNION DOWN, EXC

TOUCH ANYTHING BENEATH IT, SUCH AS TH

BE CARRIED FLAT OR HORIZONTAL, BUT AL

BE USED AS WEARING APPAREL, BEDDING

TE, AND RED, ALWAYS ARRANGED WITH THE

N FRONT OF THE PLATFORM, AND FOR DECO

BE FASTENED, DISPLAYED, USED, OR STOR

BE USED AS A COVERING FOR A CEILING.

HAVE PLACED UPON IT, NOR ON ANY PART

BE USED AS A RECEPTACLE FOR RECEIVIN

AS A SIGNAL OF DIRE DISTRESS IN INST

OUND, THE FLOOR, WATER, OR MERCHAN

ALOFT AND FREE.

RAPERY. IT SHOULD NEVER BE FESTOON
E ABOVE, THE WHITE IN THE MIDDLE, AN
ON IN GENERAL.

SUCH A MANNER AS TO PERMIT IT TO B

NOR ATTACHED TO IT ANY MARK, INSIGI

LDING, CARRYING, OR DELIVERING ANYT

THE FLAG ON HIGH!

2007
Enamel on unprimed canvas
214 x 214 cm

The Flag on High! appropriates the methodology of Frank
Stella's *Black Paintings* (1958–9), with paintbrush-width
black enamel stripes applied to an unprimed canvas in a
concentric formation dictated by the dimensions of the
canvas. Stella's seminal works announced a turn away from
gestural abstraction and a rejection of illusionism and are
widely regarded as crucial for the development of
Minimalism.[8] Despite Stella's rejection of overt content in
these works the titles he gave them alluded to the art of the
past (for example, *Arundel Castle* 1959) as well as dark and
tragic events (*Getty Tomb* 1959) and Nazi slogans (*Arbeit
Macht Frei* 1959). The imagery of *The Flag on High!*
combines Stella's approach with the cover of the Eagles'
final album, *The Long Run* (1979), thereby suggesting an
analogy between Stella's self-imposed automatism
(designed to limit the possibility of 'expression') and the
manner in which the Eagles were, by 1979, 'going through
the motions' in order to fulfil contractual obligations.[9]

The title of the work refers to Stella's appropriations of Nazi
party slogans. It is an English translation of *Die Fahne Hoch!*
which Stella used as the title of work in 1959 (now in the
Whitney Museum of American Art, New York). The impli-
cations of the phrase are intensified in relation to the work
on the adjacent wall, *In Salutation of Ashes* (cat.5) and also
Alternative Monument to Mexico City, 1968 (cat.13).

8. 'Art excludes the unnecessary.
Frank Stella has found it necessary
to paint stripes. There is nothing else
in his painting. Frank Stella is not
interested in expression and
sensitivity. He is interested in the
necessities of painting.' Carl Andre,
'Preface to Stripe Painting (Frank
Stella)' in *16 Americans*, exh cat.
MoMA, New York, 1959.

9. The Eagles were formed in Los
Angeles, California in the early 1970s.
With five number one singles and
four number one albums, the Eagles
were among the most successful
recording artists of the 1970s. At the
end of the twentieth century, two of
their albums, *Eagles: Their Greatest
Hits 1971–1975* (1976) and *Hotel
California* (1976), ranked among the
ten best-selling albums according to
the Recording Industry Association
of America. They are the best-selling
American group ever. When released
in September of 1979, *The Long Run*
debuted at number two on Billboard's
Pop Albums chart and a week later
knocked Led Zeppelin's *In Through
The Out Door* off number one. It was
the last number one album of the
1970s in America, staying there for
eight weeks. The tour to promote
the album intensified personality
differences between the band mem-
bers, made worse when founder
member Don Henley was arrested
for cocaine, Quaalude and marijuana
possession after a nude 16-year-old
prostitute had drug-related seizures
in his hotel room. Henley was subse-
quently charged with contributing
to the delinquency of a minor. The
Eagles split in mid-1980.

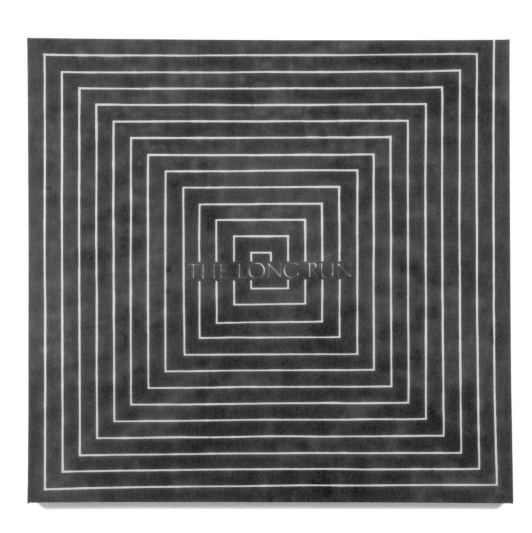

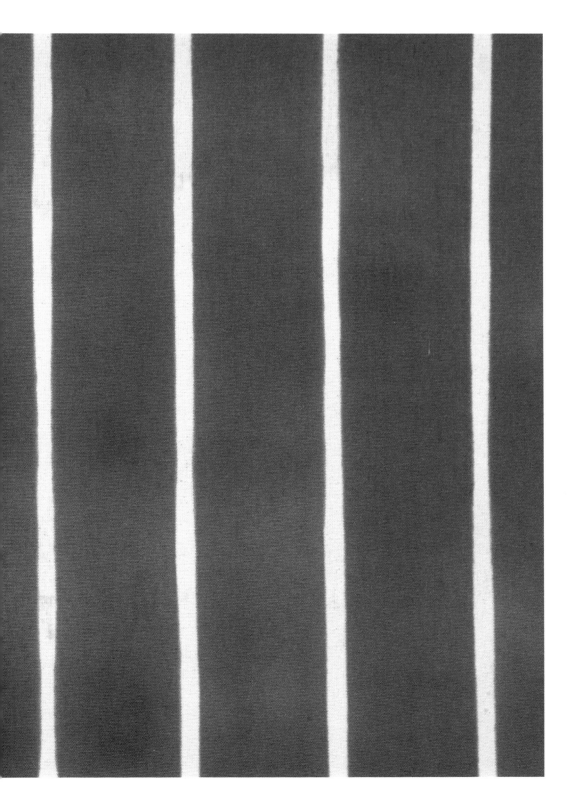

BOUNDARY FUNCTIONS

2007
Acrylic ink screenprint on glass, framed over 1957 US Navy physical world map
65 x 95 cm

Boundary Functions presents an original 1957 US Navy map showing a physical layout of the world (without political boundaries), used primarily for navigation. The map is centred on the Americas. On the glass of the frame a second map has been screenprinted. The boundary lines for countries and states as they stand in 2007 have been added and each country is identified by its comparative scale in relation to one or more of the American states (for example, '24 times the size of the Mall, Washington DC' or 'slightly smaller than Texas'); this information is drawn from the *CIA World Factbook*.[10] None of the US states are identified. When displayed, angled lighting causes the screenprinted map to cast shadowed outlines onto the Navy map behind, thereby compressing 50 years of boundary adjustments into a single picture plane.

The title of the work is taken from the title of Ted 'Unabomber' Kazcynski's mathematical PhD dissertation.[11] Kazcynski's rejection of modern society for a simple pastoral life in Montana in the 1970s was inspired by concerns that echo those of Thomas Cole (see cat.1), and perhaps exemplifies the fault-lines that began to appear in American society in the aftermath of the optimism of the post-war period.

10. *The World Factbook,* also known as the *CIA World Factbook,* is published annually by the Central Intelligence Agency of the US with almanac-style information about the countries of the world. The *Factbook* provides a brief summary of the demographics, geography, communications, government, economy, and military of 270 countries, dependencies, and other areas in the world. It is prepared by the CIA for the use of US government officials, and its style, format, coverage and content are primarily designed to meet their requirements. However, it is frequently used as a resource for student papers, websites and non-governmental publications.

11. Dr. Theodore Kaczynski (born 1942), also known as the Unabomber, carried out a campaign of mail bombings (targeting American universities and airlines) that killed three and wounded 23 from the late 1970s through to the early 1990s. Kaczynski was a brilliant mathematician but in 1969, after a promising early career, he resigned his position as Assistant Professor of Mathematics at Berkeley University. Thereafter he lived a simple pastoral life in a shack in Montana. Kaczynski's *Industrial Society and Its Future* (commonly called the 'Unabomber Manifesto') was published by demand in both the *New York Times* and *Washington Post* in 1995. In this thesis he argued that his actions were intended to focus attention on the dangers of technological progress, which he believed would lead to the downfall of man. Kaczynski hoped that his actions would inspire others to fight against this growing threat.

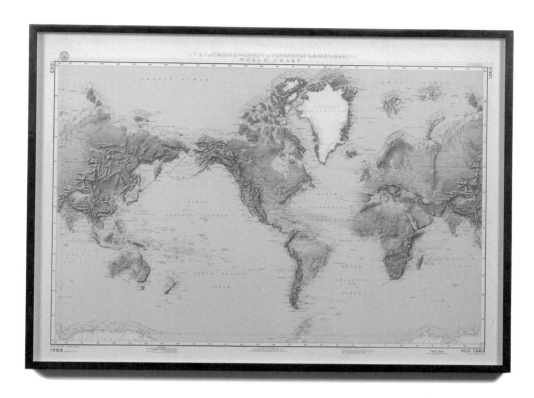

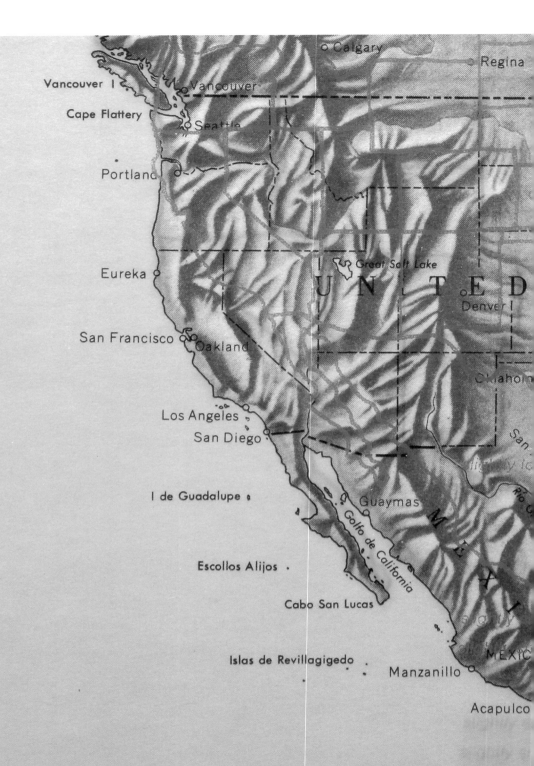

Winnipeg

Moosonee o
Rupert House

Duluth o
Sault Ste Marie
OTTAWA
Quebec
Montreal
St Lawrence R.
St

T A T E S

Minneapolis o

Milwaukee
Detroit
Toronto
Buffalo
Portland
Boston
Cape Cod
Cape S

Chicago
Cleveland
Philadelphia
New York

Cincinnati
Baltimore
WASHINGTON

St Louis

about one-third the size

Norfolk

Memphis

Mississippi

Cape Hatteras

Charleston
Savannah
Bermuda •

slightly smaller than Connec

twice the size of Wa

Pensacola
Jacksonville

Okeechobee

slightly smaller than Pennsylva

New
Orleans

slightly more tha

Galveston

Tampa

1.5 times the size of Washington DC

GULF OF MEXICO

slightly smaller than Maryland

sligh

Key West
Miami

slightly smaller than Connectic

Brownsville

slightly smaller than Massachusetts
Andros
BAHAMA IS

Tampico

n Tennessee
Progreso

HABANA

slightly larger than six times the size of Washington

slightly larger than Tennessee

n Massachusetts

CUBA

DOMINICAN REP

San Juan

Virgin

Veracruz

Cayman Is

slightly smaller than the state

HAITI

Trujillo

PUERTO RICO

more than five times the size of Washington

JAMAICA

Kingston

PORT-AU-PRINCE

Domini

smaller than West Virginia

BR HONDURAS

slightly smaller than South Carolina

sligh

HONDURAS

TEGUCIGALPA

CARIBBEAN SEA

St

GUATEMALA
SALVADOR

NICARAGUA

Aruba

Faeroe Is

Bergen

slightly less than Shetland the size of Massa

Stavanger

es the size of Washington, DC Orkney Is

slightly smaller than Or

larger than West Virginia Hebrides SCOTLAND

Rockall NORTH SEA Skager

slightly less than twice the size of New Jersey DENMARK

BRITISH Ireland Glasgow Edinburgh

ISLES Esbjerg

about the size of Maryland ENGLAND

slightly smaller than NETH

Irish Hull GRAVENHAGE Amsterdam

DUBLIN Sea

IRELAND Liverpool LONDON orado Rotterdam

about 6 times the size of Washington, D

slightly less than twice the size slightly smaller BON

Cóbh slightly smaller

Mizen Hd Lands End English Channel BELGIUM BRUXELLES

Plymouth Le Havre PARIS Fr

2.5 times the size of Washington, DC

Brest SWITZ BERN

about 0.7 times the size FRANCE in

Lorient

ghtly smaller than Indiana Bay of Biscay Milano

more than twice the size of Oregon Bordeaux

El Ferrol Marseille

Cabo Finisterre Bilbao Genova

Vigo ANDOR Corsica

of The Mail in Washington Barcelona abou

Pôrto MADRID

PORTUGAL Balearic Geor

SPAIN larger Islands ME

LISBOA Valencia

slightly larger than California Murcia

Cabo de São Vicente Cádiz Bizerte

slightly smaller than New Hampshire

HELSINKI

slightly larger than West Virginia

Ladozhskoye
Ozero

STOCKHOLM

Gulf of Finland

slightly larger than West Virginia

Leningrad

ESTONIA

slightly smaller than Kansas

Göteborg

Gulf of Mexico

BALTIC SEA

Rīga
LATVIA

smaller than Montana

than Rhode Island

LITHUANIA

MOSKVA

Smolensk

slightly smaller than

Gdansk twice the size of New Hampshire

Szczecin

Minsk

slightly smaller than Maine slightly larger than Maryland

WARSZAWA

Brest

Indiana

twice the size of New Jersey

Łodz

POLAND

than West Virginia

Kiyev

Khar'kov

Kraków

slightly smaller than Ore

Dnepr

Dnepropetrovsk

CZECHOSLO KIA

than Kentucky

Zaporozh'ye

Stalino

WIEN

BUDAPES

larger than Tennessee

AUSTRIA

HUNGARY

Odessa

Rosto

RUMANIA

Azovskoye
More

BEOGRAD

slightly larger than Texas

Venezia

YUGOSLAVIA

BUCURESTI

Sevastopol'

Kerch

slightly smaller than Alabama

ALBANIA

BULGARI

BLACK SEA

TIRANE

SOFIYA

Istanbul

Batumi

Izmir

ANKARA

TIRT

Sicily

ATHINAI

UNTITLED (EVERY VICTIM AND MANNER OF DEATH IN THE FRIDAY THE 13TH FILM SERIES)

2006–2007
2,000 stacked lithographic prints on paper, 14lb weight
90 x 64 x 27 cm

Featuring a stack of prints depicting each of the victims in the long-running horror film series,[12] *Untitled...* recalls Cuban artist Felix Gonzalez-Torres's installations which invite the viewer to take a piece of the work with them; packaged sweets from a pile in the corner of an exhibition space, or from stacks of unlimited edition prints.[13] Here, however, such a possibility is subverted due to the addition of a fourteen-pound weight.

The work is laid out in the style of a typical Conceptual Art project – such as Ed Ruscha's *Every Building on the Sunset Strip* (1966) – though also references High School yearbooks and newspaper spreads featuring casualties of war and terrorist attacks. This is also reflected in the choice of type – Optima – most famously used for Maya Lin's Vietnam War Memorial in Washington DC.[14]

12. There have been eleven films in the series so far, beginning with *Friday the 13th* (1980) and culminating with *Freddy versus Jason* (2003). The 'hero' of the series is the hockey mask-wearing serial killer Jason Voorhees.

13. A frequent reading of Gonzalez-Torres's work is that the processes his works undergo (lightbulbs expiring, stacks of prints dispersing) are a metaphor for the process of dying.

14. '*The Friday the 13th films are central to my 'experience' of the Vietnam*

War. Obviously I was not yet alive so it was introduced to me through the consequent cultural output – in which it often figures as sublimated content – such as the glut of American horror films that seemed to spring from the late 1970s and which largely formed my preliminary introduction to American culture.' Artist's notes for *A Dream Deferred*.

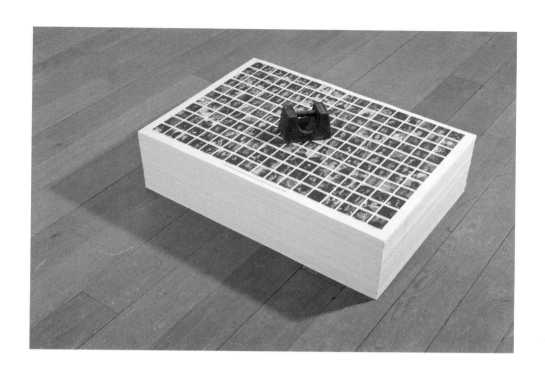

BARRY
stomach (1980)

BILL
pinned to door with arrows (1980)

BRENDA
killed off-screen, thrown through
window (1980)

kni

VICKIE
ed (1981)

ALI
bludgeoned with a wrench, later
recovers and is macheted (1982)

ANDY
macheted in half while walking
on hands (1982)

impaled

S. JARVIS
-screen (1984)

NURSE MORGAN
gutted with a scalpel (1984)

PAUL
spear to the groin (1984)

garden h

JOEY
rith an axe (1985)

JUNIOR
decapitated with a cleaver (1985)

LANA
axe to the chest (1985)

ice
Tor

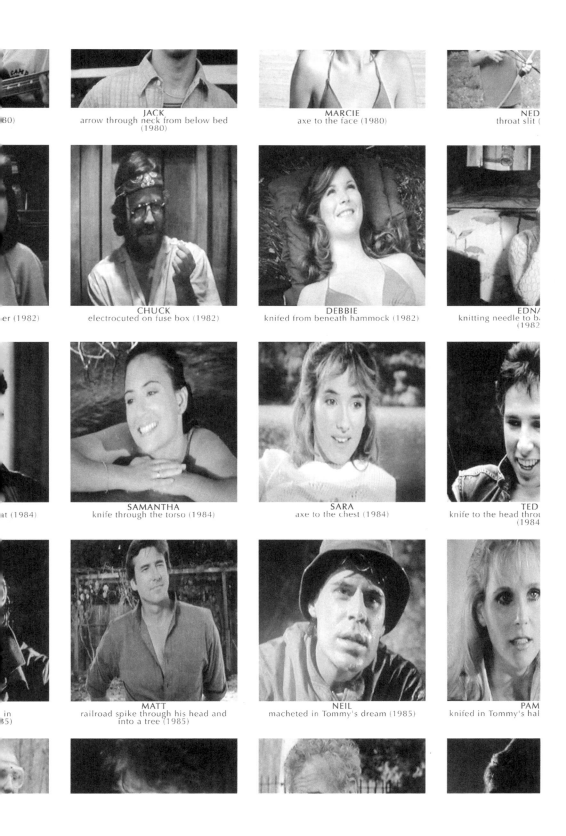

0) JACK
arrow through neck from below bed
(1980)

MARCIE
axe to the face (1980)

NED
throat slit (

er (1982) CHUCK
electrocuted on fuse box (1982)

DEBBIE
knifed from beneath hammock (1982)

EDNA
knitting needle to b.
(1982

at (1984) SAMANTHA
knife through the torso (1984)

SARA
axe to the chest (1984)

TED
knife to the head throu
(1984

in
5) MATT
railroad spike through his head and
into a tree (1985)

NEIL
macheted in Tommy's dream (1985)

PAM
knifed in Tommy's hal

ANOTHER HEAP OF LANGUAGE

2004–2007
Stack of 18 used copies of *A History of the Modern World* by R.R. Palmer,
et al. with user annotations and permanent marker erasure with plinth
and Perspex top
Book stack 28 x 22 x 11 cm, overall 110 x 48 x 42 cm

Eighteen copies of R. R. Palmer's *A History of the Modern World* have been dissected and Shovlin has used reader annotations to determine an editorial process and thereby revise the content: Anything not underlined, annotated or marked has been erased. Unlike previous works using this strategy – for example *Ways of Seeing* (2004) or *The Origin of the Species* (2003–6) – in which the pages of the books were framed and displayed, thus offering a fragmented but readable text, here the result of the process remains unseen. The books are displayed as a stack, hence the title and the allusion to the Robert Smithson drawing *A Heap of Language* (1966), now in the Museum Overholland, Niewersluise.

Despite the book's title, it actually presents an overview of mostly European history and is the standard history textbook used in American high schools. Of the eighteen copies that constitute the work, the earliest is dated 1955, whilst the most recent edition was published in 2000, thereby establishing a correlative timescale with the maps that constitute *Boundary Functions* (cat.7) and suggesting a Cold War history of international relations and their various revisions.

sixth edition

A History
of
the
Modern
World
Since 1815

R. R. PALMER
JOEL COLTON

UNTITLED

2007
Cibachrome
38 x 25 cm

Shovlin has re-photographed a late 1950s school photograph
of his mother, setting it against the typically English suburban
backdrop of her home. In the original photograph Valerie is
seated in front of a world map and in the foreground is a
book entitled 'GEOGRAPHY'. The work serves to locate both
Boundary Functions (cat.7) and *Another Heap of Language*
(cat.9) within the context of educational knowledge, suggest-
ing the transfer of information from generation to generation.

Stylistically the photograph references the work of American
photographers such as William Eggleston and Stephen Shore,
who pioneered the use of colour photography in the 1970s.[15]

15. Eggleston's 'uncontrived realism
[represents] an indiscriminate
survey of the people and everyday
objects surrounding him – a personal
and intimate record of the American
South.' It has been suggested that
'the mundane subject matter and
the slight unease that these […]
images provoke is reminiscent of
David Lynch's films, which reveal a
sense of disquiet beneath the veneer
of the suburban idyll.' Emma Dexter
and Thomas Weski eds., *Cruel and
Tender: The Real in the Twentieth
Century Photograph*, Tate Modern,
2003, p.259.

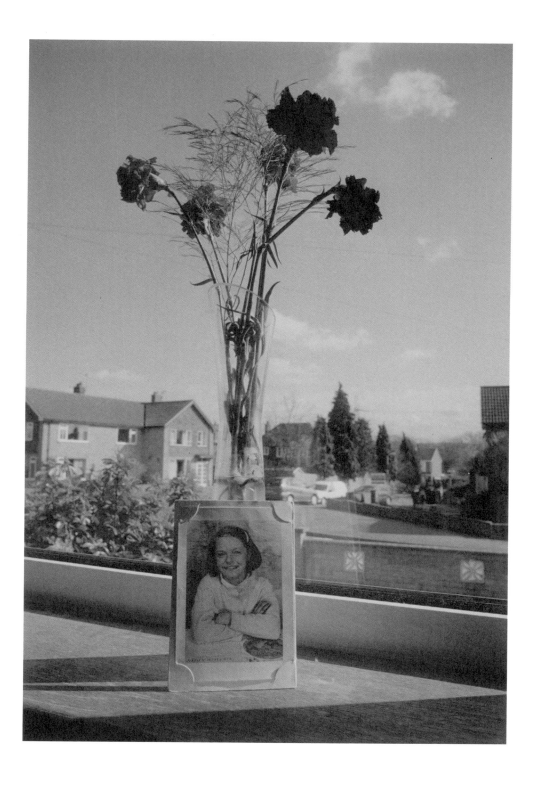

AT HOME ABROAD

2007
Pine tar and turpentine on paper and wood
153 x 153 cm

At Home Abroad is a monochrome treatment of the cover of
the album *Agent Provocateur* (1984) by the Anglo-American
band Foreigner.[16] The brightly graphic original cover design
has been reduced to relief profiles with no colour differen-
tiation. The painting thus references the important series of
'black paintings' made by Ad Reinhardt, Robert Rauschenberg,
and others in America in the 1950s and 60s.[17] While the
dripped facture of *At Home Abroad* is suggestive of Rauschen-
berg's work, Shovlin has used the 5 x 5 foot format repeatedly
used by Reinhardt for the signature black paintings – he
called them 'last paintings' – which he worked on exclusively
from 1953 until his death in 1967.[18] Despite their seeming
hermeticism Reinhardt's black paintings were not created in
a vacuum. The kind of profound, self-reflexive abstraction he
advocated can be understood as a product of, and reaction
to, the climate of Cold War America. Despite the iconoclasm
of his aesthetic discourse, Reinhardt was actively engaged
in political and social issues throughout his life. He sought
to create an art form that – in its monochromatic purity and
moral aestheticism – could overcome the tyrannies of
oppositional thinking.

At Home Abroad is realised using pine tar – a material that
was historically used for tarring and feathering. Subject,
method and title thus introduce a series of potential readings
in relation to notions of foreignness, and to the Civil Rights
struggle in the US in the 1960s and 70s.

16. *Agent Provocateur* was
Foreigner's fifth album and was
released in 1984. A concept album,
the songs tell the story of a spy.
The album contains the band's
biggest hit single, 'I Want to Know
What Love Is'.

17. See Stephanie Rosenthal, *Black
Paintings,* exh cat. Hans der kunst,
Munich, 2006.

18. For example, *Abstract Painting
No.5* (1962), Tate, London; *Abstract
Painting* (1960–66), Solomon R.
Guggenheim Museum, New York.

Reinhardt described the black
paintings as: '…free,
unmanipulated, unmanipulatable,
useless, unmarketable, irreducible,
unphotographable, unreproducible,
inexplicable icon(s).' Reinhardt's
aesthetic of denial reflected his
belief that Modernism itself was a
'negative progression.'

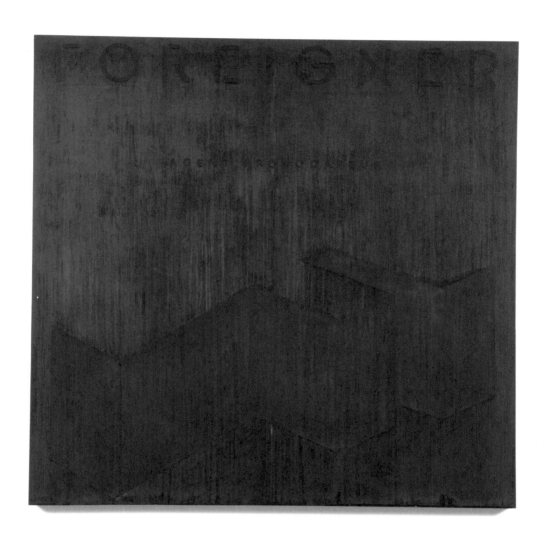

FALL (HISTORIC)

2007
Pencil on paper
Two parts, each 44 x 33 cm

A diptych featuring two sides of the same page from the book, *Great Sporting Moments* (2003), the right panel presents an upturned image of the long jumper Bob Beamon, who famously smashed the world long jump record at the 1968 Mexico City Olympics with a jump that stood as the record for almost 25 years. His sporting achievement was largely overshadowed by the political protest made by Tommie Carlos and John Smith as they received their medals for the 200 metres (see cat.13). The left panel features a mirrored edit of the reverse of the Beamon page, relating the actions of Smith and Carlos. The background of the Beamon image has been erased, thereby stripping his jump of its historical context. In addition almost all of the text relating the Smith/ Carlos protest has been excluded, leaving only the date of the event and the text from a banner in the crowd: 'WHY BE A HERO IN MEXICO AND A SLAVE AT HOME?'

The title is one of many references to the Dutch Conceptual artist Bas Jan Ader that appear throughout *A Dream Deferred*.[19]

19. Bas Jan Ader made a number of works about falling, including *Broken Fall (Organic)* (1971), in which the artist is pictured falling or jumping from a tree into a river. This work suggests an analogy with Shovlin's use of appropriation, being itself a revision or reworking of Yves Klein's famous *Leap Into the Void* (1960).

'WHY BE A HERO IN MEXICO AND A SLAVE AT HOME?'

- Tommie Smith
- Mexico City Olympian, Mexico
- 16 October 1968

A placard in the crowd read, 'Why be a hero in Mexico and a slave at home?'

ALTERNATIVE MONUMENT TO MEXICO CITY, 1968

2007
Crayola-coloured wax casts of two gloved forearms, four bare forearms, three
pairs of socked lower legs, and a pair of bare lower legs with plinth
100 x 100 x 70 cm

On 17 October 1968, during the Summer Olympics, the Black
American athletes Tommie Smith and John Carlos achieved
first and third place in the 200 metres final. Smith's time was
a new world record. They then staged a notorious and iconic
protest from the medal podium. The two athletes received
their medals shoeless, but wearing black socks, to represent
black poverty. Smith wore a black scarf around his neck to
represent black pride and Carlos wore a string of beads, to
commemorate black people who had been lynched. When
the Star Spangled Banner played, Smith and Carlos delivered
clenched-fist Black Power salutes with heads bowed, a ges-
ture which became front page news around the world. As
they left the podium they were booed by the crowd.[20] The two
athletes were later stripped of their medals and expelled
from the Games.

Alternative Monument to Mexico City, 1968 is comprised of a
series of rough casts of arms and legs made from wax, thus
recalling sculpture by – among many others – Robert Gober,
Bruce Nauman, and Paul Thek. Included in the wax mix are
fifty assorted Crayola colours (which are marketed in the US
as 'America's Favorite Colors', see cat.25). Each of the limbs
refer to one of the eight athletes who were acknowledged as
making protests, one way or another, at the 1968 Olympics.[21]

Shovlin's alternative monument reacts against the 'official'
monument at San Jose University in California, which
recreates the famous scene with a space for the viewer to
take their place on the podium (in place of Australian silver-
medallist Peter Norman).

20. Smith later said 'If I win, I am
American, not a Black American.
But if I did something bad, then they
would say I am a Negro. We are black
and we are proud of being black.
Black America will understand what
we did tonight'.

21. In addition to Smith and Carlos,
these were: Bob Beamon, Ralph
Boston, Lee Evans, Ron Freeman,
Larry James and Vince Matthews.

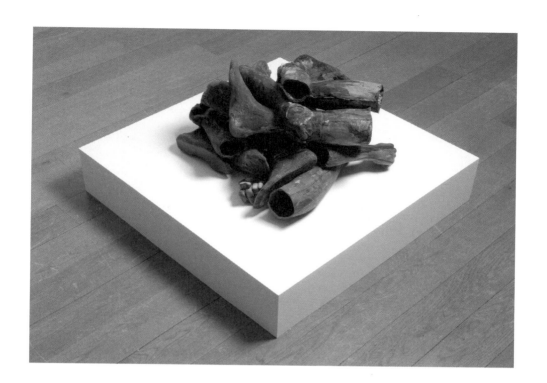

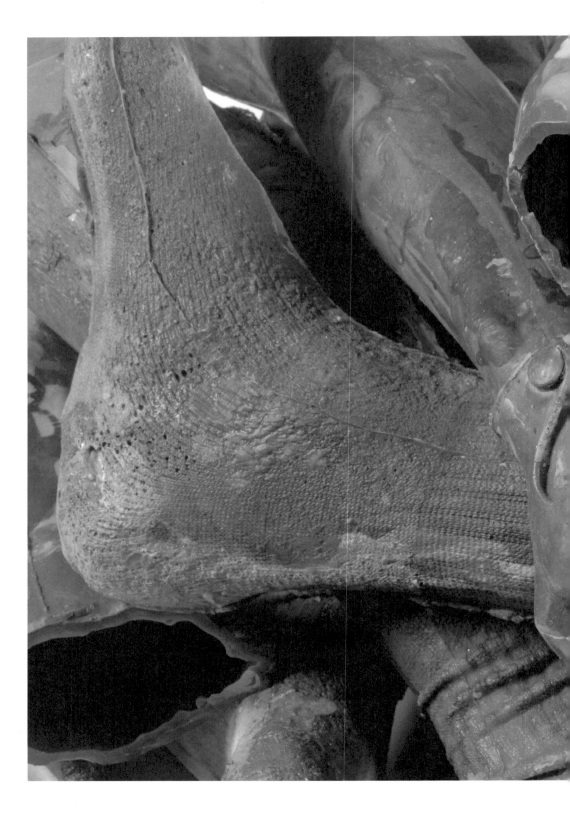

SOMEDAY (AUGUST 29, 1968)

2006–2007
Erased compressed charcoal
114 x 114 cm

The drawing takes the cover design for Chicago's eponymous fourteenth album (released in 1980) and reverses it: the fingerprint of the original is inverted from black to white and the drawing is developed through the gradual erasure of a layer of black charcoal. Technically the work recalls Robert Rauschenberg's *Erased De Kooning Drawing* (1953) now in the collection of San Francisco Museum of Modern Art, a work which is often interpreted as embodying the oedipal desire to kill one's father (or heroes).

The band history mirrors the central thematic of the exhibition; Chicago started out as a highly idiosyncratic, political act before 'selling-out' with music like that featured on this release (which gathered them greater success).[22] The work's title is taken from a track on their first album, which references the riots of the 1968 Democratic National Convention held in Chicago following the death of Bobby Kennedy.[23] This reference in itself opens up a larger context of protest – famously the arrest and subsequent acquittal of the 'Chicago Seven' protestors and the accusations levelled at the police in relation to their use of force to quiet the rowdy protesting crowds.[24]

In the exhibition the framed work is positioned so that it literally reflects the left panel of *Fall (Historic)* (cat.12), mirroring the reversed text so that it reads legibly, and opening to question the 'whitewashing' of history that the Black Panther Party accused the mainstream American press of.

22. Chicago were formed in 1967 in Chicago, Illinois. The band began as a politically charged, sometimes experimental rock band and later moved to a softer sound, becoming famous for producing a number of hit ballads. They had a steady stream of hits throughout the 1970s and early 1980s.

23. The 1968 National Convention of the US Democratic Party was held in Chicago, Illinois in August 1968. The convention achieved notoriety due to clashes between protesters and police. The convention was inflamed by a series of interventions by the counter culture, including a raucous now-legendary eight-hour gig by the MC5 and, the 'nomination' of *Pigasus* as presidential candidate (Pigasus the pig was a satiric candidate for President of the USA for the Youth International Party, aka the Yippies). The subsequent Walker Report to the National Commission on the Causes and Prevention of Violence assigned blame for the mayhem to the police force, calling the violence a 'police riot'.

24. Eight of the protesters – Abbie Hoffman (see cat.18), Tom Hayden, Dave Dellinger, Rennie Davis, John Froines, Jerry Rubin, Lee Weiner, and Black Panther Bobby Seale – were charged with conspiracy in connection with the violence at the convention. They were known collectively as the 'Chicago Eight'; however, Seale was tried separately after a mistrial was declared in his case, thus the group became known as the 'Chicago Seven'. In February 1970, all seven defendants were acquitted on the charge of conspiring to incite a riot, but five were convicted of incitement as individuals. All of the convictions were eventually overturned.

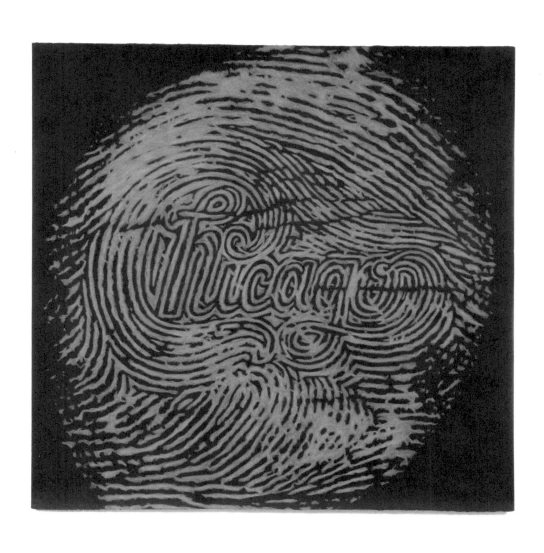

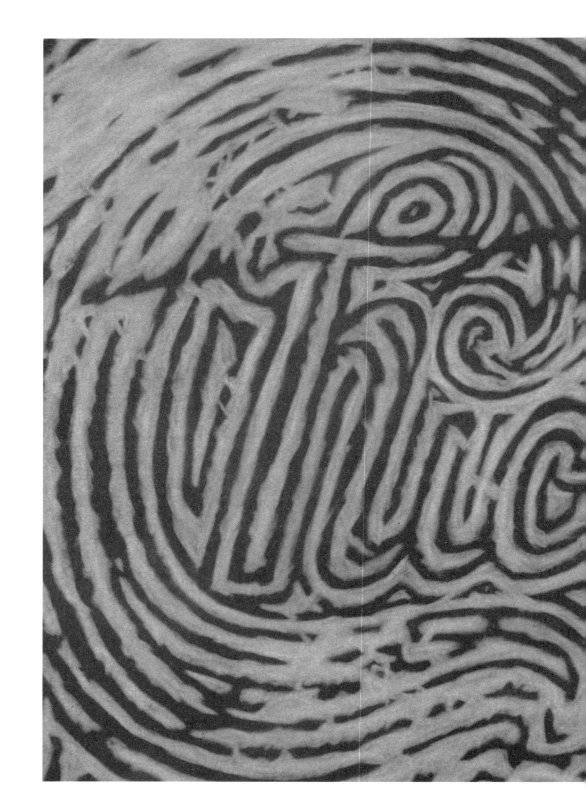

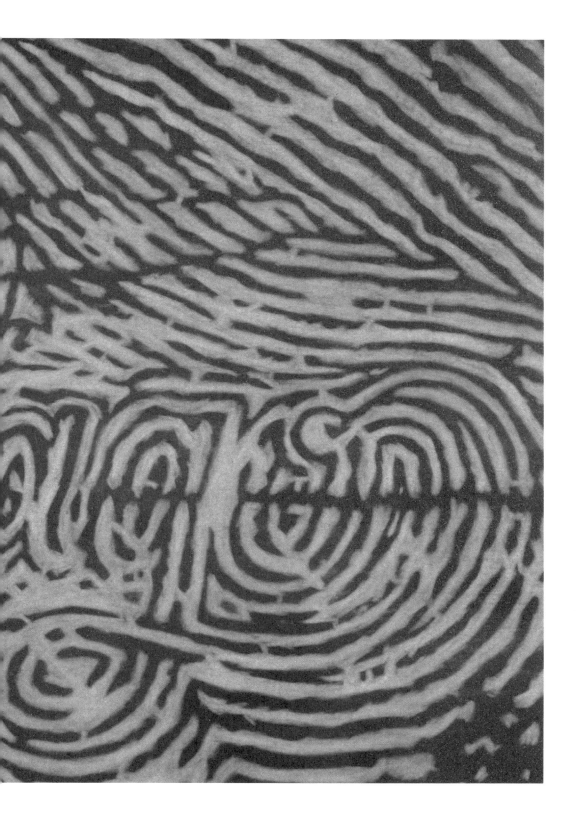

SECOND

FLOOR

BLUE-EYED PHILLY SOUL (YOU MAKE MY DREAMS)

2007
Oil on three canvases
228 x 224 cm

This three-part painting takes as its source the back cover of
Daryl Hall & John Oates' *Rock 'n' Soul Part 1* (1983).[25] The title
refers to Hall & Oates' sound – known as 'white-boy' or
'blue-eyed' soul – but also places the work in a geographical
sequence articulated by the paintings on the top floor of the
exhibition (cats.17 and 20), outlining a westward migration
from Philadelphia to the Mid-West to, finally, the 'Last
Resort': California.

The graphic design of the album cover has been fragmented
and reconfigured to create a formal reference to Ellsworth
Kelly's joined canvases of the 1970s.[26] Of the information given
on the original album's reverse, all that remains is the solitary
track listing, 'You Make My Dreams'. This resonant phrase
points to a central thematic of the exhibition: dreams, ideals
and their subsequent deferral or, in this case, fragmentation.

25. *Rock 'n' Soul Part 1* is essentially
a greatest-hits package. The album
peaked at number seven in the US
and the two new songs on the LP
both became top-ten hits.

26. 'The form of my paintings is the
content' Ellsworth Kelly, *Notes*, 1969

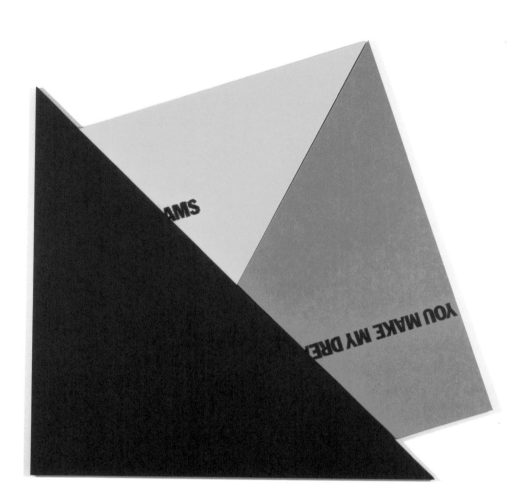

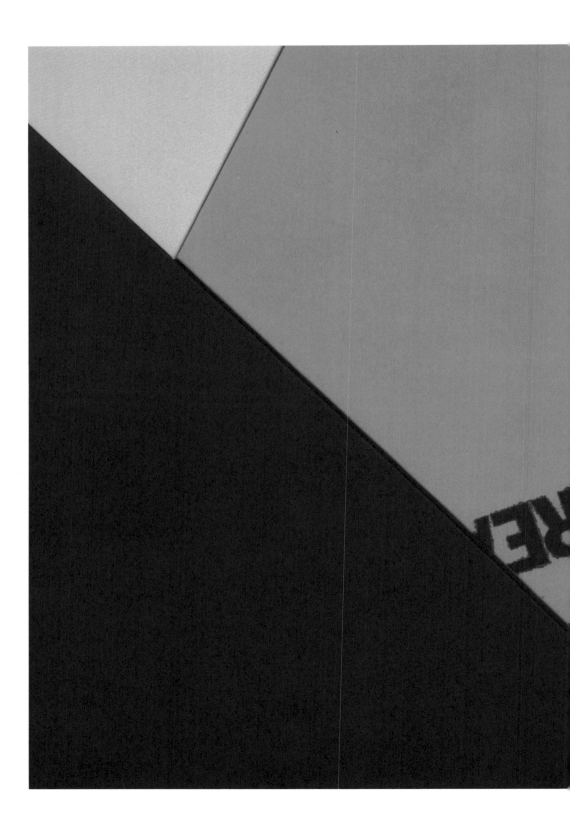

YOU MAKE MY

THE BIRTH OF A NATION

2007
Acrylic ink screenprint on mirror
171 x 122 cm

Taking a collection of user comments from the Internet
Movie Database (IMDB) for the 1915 film *The Birth of a Nation*,
Shovlin has screenprinted each of the 80 or so reviews onto
a full-length, human-height mirror.[27] *The Birth of a Nation*,
directed by D.W. Griffith, is regarded as a landmark in film
history, renowned for its ground-breaking technical achieve-
ments and introducing many new concepts to the language
of film.[28] However, the film is widely derided for the perceived
racism of its narrative, which tells the story of the American
Civil War from the Confederate point-of-view. The reviews
included represent a fragment of a continuing debate about
artistic value versus moral and political wrong. The texts are
taken directly from the website, with author credits and
spelling mistakes intact, and, in terms of geographical origin,
span from east to west the breadth of the US. The sequence
of American user comments is occasionally interrupted by
the addition of a review from a non-US citizen.

27. *'The internet, especially in this
context, can be viewed as a contem-
porary metaphor for the democratic
tradition of free speech (that the new
world US established itself upon), so
that a fluid consensus is created. In
printing the reviews onto a mirror,
it's hoped that a more self-aware act
of reading – and hence participating
– becomes possible.'* Artist's notes for
A Dream Deferred.

28. *The Birth of a Nation* is set during
the American Civil War and is based
on Thomas Dixon's novel *The
Clansman* (1905). It is controversial
for its glorification of the Ku Klux
Klan, which continues to use it as a
recruiting tool. The title was
changed from *The Clansman* to *The
Birth of a Nation* to reflect Griffith's
belief that before the American Civil
War the United States was a loose
coalition of states antagonistic
toward each other, and that the
Northern victory over the breakaway
states in the South finally bound the
states under one national authority.

THE BIRTH
(D.W. Gri...

...ature length movie.

...h of a Nation, starring Lillian Gish, Mae Marsh, Henry B. Walthall, and Mariam ...

...er.

...d States.

...ses meant to say something is 'Politically Correct? 17 July 2000
...DanCurtis.nyc232@angelfire.com from Greensboro, NC

...

paradox when an intellectual idiot is a cinematic genius, 12 February 2000

Author: cow from Detroit, Michigan

*** This comment may contain spoilers ***

(This may have some spoilers in it, but I'd be surprised if anyone saw this film without knowing all about it already.)

I can thank D.W. Griffith for creating film as an art form, for maturing the medium. However Birth of a Nation did far more damage than good as a film. Although the American feature film, feature films were inevitable anyway. All of the innovations the film had already been used in Griffith's previous films and would continue. It cannot be said that Birth of a Nation was socially acceptable in 1915. It drew demonstrations against its racism, condemnation by the American president and was banned in states. It is directly responsible for the rise of the KKK in the South and was used as a recruitment film for the KKK until the 1960s. It is an unfortunate story (how the KKK saved white women from rape, freed the atrocities perpetrated by black "monkey men" after the end of the Civil enjoyed this feature film. However you cannot separate this story from this would be to ignore the damage this film has caused in U.S. society - damage today. That would be irresponsible.

MIDWESTERN (GETTING BACK TO MY ROOTS)

2007
Acrylic on unprimed canvas
183 x 183 cm

Midwestern's circular design is taken from the cover of Bob
Seger's album *Smokin' O.P.S.* (1972), which in turn appro-
priates the Lucky Strike cigarettes logo. For the artist Seger
represents a 'return to roots', a purveyor of staunch, hearty
rock to a blue collar audience.[29] The album itself is a covers
album (O.P.S. stands for Other People's Songs), which suggests
an analogy with the strategies of appropriation and trans-
formation which Shovlin uses throughout *A Dream Deferred*.

The painting is realised using Kenneth Noland's staining tech-
nique, applying thin layers of dilute acrylic to an unprimed
canvas.[30] Seger's name is retained on the painting but the
album title has been removed from the inner circle. A further
layer of reference is suggested by the resemblance of the
work to a target, a motif most famously used by Jasper Johns
from the 1950s onwards.[31]

29. After years of local Detroit-area
success starting in the mid-1960s,
Bob Seger achieved national and
then international success in the
mid-1970s, which extended into the
1980s, finally reaching its zenith in
the 1990s. Best known for his work
with The Silver Bullet Band, a group
he formed in 1974, Seger's many hits
include his signature song 'Old Time
Rock and Roll'.

30. Noland is usually identified with
Colour Field Painting and Hard Edge
Abstraction, movements prominent
in the US in the 1950s and 60s that

sought to rid art of superfluous
rhetoric. Noland's subtle colour
relationships and 'cool' handling,
eliminating recognisable imagery,
presents abstraction as an end in
itself. In this sense his work
articulates a classical Modernist
idealism.

31. See *Target with Four Faces* (1955),
Museum of Modern Art, New York;
Target (1958), Collection of the Artist.

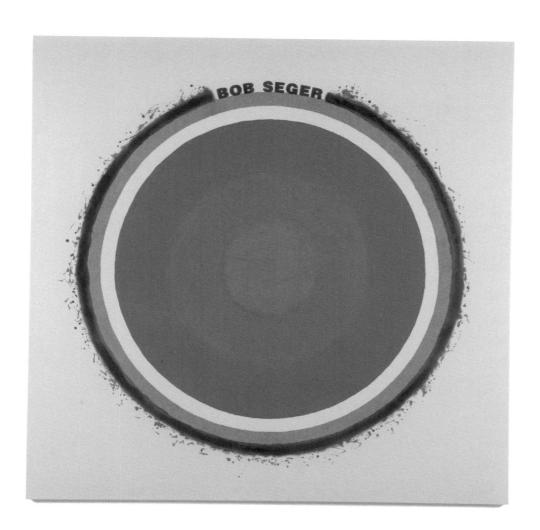

A GHOST IS BORN

2007
Pencil and graphite on paper
50 x 40 cm

A Ghost is Born depicts a photocopy of Abbie Hoffman's (1936–1989) obituary in *The Washington Post*. Hoffman came to prominence in the 1960s and has remained a symbol of the radical activism of that decade to the present day. Founder of the Yippies, during the Vietnam War Hoffman used deliberately comical and theatrical tactics to protest; for example, staging a mass demonstration in which over 50,000 people unsuccessfully attempted to use psychic energy to levitate The Pentagon.[32] Hoffman was arrested and tried for 'conspiracy' and 'incitement to riot' as a result of his role in anti-Vietnam war protests during the 1968 Democratic National Convention in Chicago and was one of the Chicago Seven (see cat.14).[33] Hoffman suffered from life-long depression and finally committed suicide by barbiturate overdose in 1989.

The image accompanying the article shows the elderly 'respectable' (he is dressed in a suit) Hoffman, beside which is a quote from the newspaper copy about the perils of a younger generations' obsession with nostalgia: 'When you see young people nostalgic for a youth they didn't even experience, it's a little sad. They're supposed to be out making one for themselves.' The article also notes that Hoffmann named his third child, born in 1971, 'America'.

32. The Youth International Party (whose adherents were known as Yippies) was an offshoot of the free speech and anti-war movements of the 1960s. The Yippies presented a more radically youth-oriented and countercultural alternative to those movements. They employed theatrical gestures – such as advancing a pig as a candidate for President in 1968 – to mock the social status quo. In 1971, Hoffman published *Steal This Book,* which advised readers how to live for free. Many followed his advice and stole the book, leading many bookstores to refuse to carry it.

33. At the trial, which was presided over by Judge Julius Hoffman (no relation, a fact which Abbie joked about throughout), Hoffman's courtroom antics frequently grabbed the headlines. He appeared in court dressed in judicial robes and was sworn in as a witness with his hand giving the finger. Hoffman and four of the others (Rubin, Dellinger, Davis, and Hayden) were found guilty of intent to incite a riot while crossing state lines. At sentencing, Hoffman suggested the judge try LSD and offered to set him up with a dealer he knew. Each of the five were sentenced to five years in prison and a $5,000 fine. All convictions were subsequently overturned by the Appeals Court.

ABBIE HOFFMAN

been involved in an unsuccessful
fight to stop the Philadelphia

lege campuses and from book to:
aries. His latest book was "Str
This Urine Test."

He had characterised curr
college campuses as "bastions
rest," and in an appearance
week at Vanderbilt University s
he was disturbed by the interes
today's young people have in the
1960s.

"Nostalgia is a sign of age," he
said. "We're not showing about our
youth. When you see young people
nostalgic for a youth they didn't
even experience, it's a little sad.
They're supposed to be out making
one for themselves."

Mr. Hoffman's first marriage, to
Sheila Hoffman, ended in divorce.
They had two children, Andrew and
Amy.

In 1967 he married fellow radical
activist Anita Kushner. They named
their child, born in 1971, America.

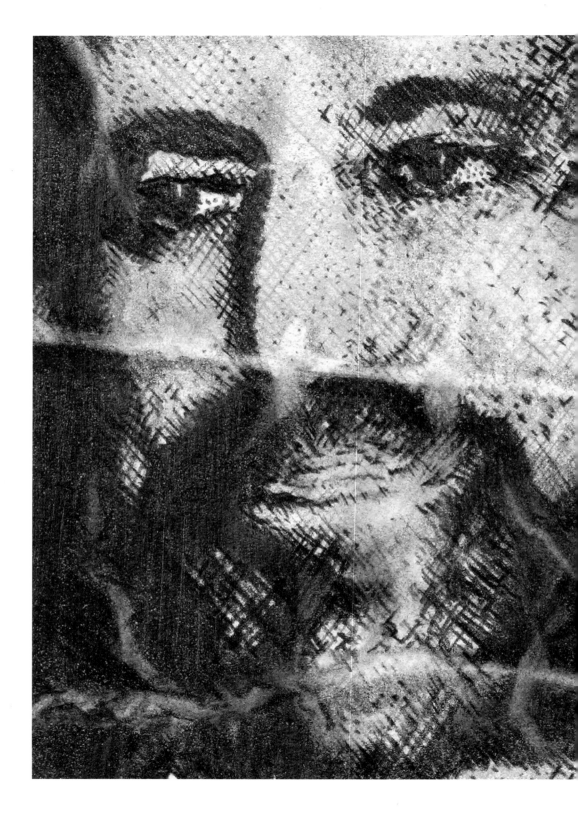

week at Van

he was dist

today's your

1960s.

"Nostalgia

said "We're

youth. "When

nostalgic for

even experie

They're supp

one for them

Mr. Hoffm

FAREWELL TO FARAWAY FRIENDS

2007
Cibachrome
45 x 31 cm

A photograph in the tradition of the Eggleston-style snapshot
(see cat.10), reuniting two Polaroids of Shovlin's parents from
the 1970s. Each parent is absent from the other's photograph
(presumably because each took the photograph of the
other). Shovlin's re-photograph is composed to appear spon-
taneous, with the original photographs casually strewn on a
stack of papers and envelopes amongst flowers. Pictorially it
reprises *Are you reelin' in the years…* (cat.2), where both
parents are present in the same picture. The title, though
clearly a reference to how the Shovlins *were* as opposed to
how they *are,* is taken from a self-consciously nostalgic and
romantic 1971 photographic work by Bas Jan Ader, where
the artist is pictured against a sunset, gazing out to sea. The
original photograph of Valerie Shovlin pictures her leaning
against the rail of a ship on the sea.

Farewell to Faraway Friends is realised in Cibachrome, a dye
destruction positive-to-positive photographic process used
for the reproduction of slides on photographic paper. The
process was developed in the 1960s, and provides the
saturated colours associated with American documentary
photography of the 1970s.

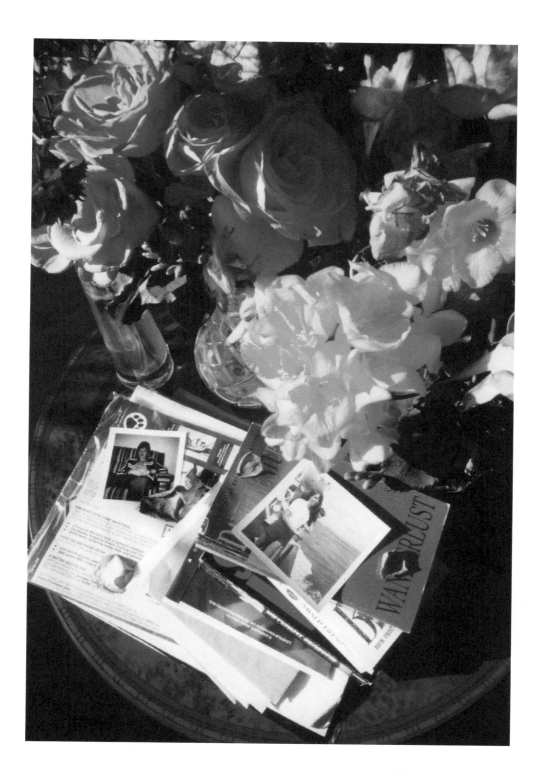

THE LAST RESORT / THE BLACK ROOM

2007
Acrylic on canvas
250 x 250 cm

The Last Resort represents the cover of *Hotel California* (1976) by the Eagles.[34] Crucially, the background landscape (but not the title) has been reversed and is also significantly darkened and blurred.[35] The painting is executed in spray acrylic, the same technique employed for *The Course of Empire* (cat.1). As with that work, the finish references Ed Ruscha's landscapes of the 1980s, which often evoke apocalyptic themes.

The album has a special status in the Shovlin family collection: both Valerie and Denis consider it amongst their favourite albums. The album's central themes – innocence (and the loss thereof), the dangers, temptations, and transient nature of fame, the dereliction of America's natural resources – were regarded as timely at the albums' release.[36] Shovlin suggests that, despite their noble intentions, the Eagles, one of most financially successful and hedonistic bands of all time, were as guilty as anyone of the 'crimes' they wrote about. Indeed the story of the Eagles can be seen as a metaphor for the entire historical narrative that Shovlin's project attempts to reveal, that of noble origins (they began as country star Linda Ronstadt's backing band) subverted by ambition and the lure of commerce. Within the exhibition, *Hotel California* is positioned as the quintessential American album, with all the inherent contradictions that embodies.

Shovlin's painting is named after the album's closing track, 'The Last Resort', a song that underscores the entire album's thematic of 'how the west was won … and lost' with a narrative flowing from Providence, Rhode Island to California: '…you call someplace paradise, you kiss it goodbye.'[37]

34. *Hotel California* was the Eagles' fifth album and became a major commercial hit; since its release in late 1976, it has sold over 16 million copies in the US alone and is one of the best-selling albums of all time. The album was at number one in America for eight weeks between late 1976 and early 1977, and included two tracks which became number one hits as singles on the Billboard Hot 100: 'New Kid in Town' and 'Hotel California'.

35. The cover image is of the Beverly Hills Hotel. There are a number of theories as to the meaning of the album cover. For example, the hotel of the title has been linked to either a mental hospital, or the headquarters of Anton LaVey's Church of Satan.

36. In an interview with Dutch magazine *ZigZag* shortly before the album's release, Eagles drummer Don Henley said, 'This is a concept album … we figured that we were obliged to make some kind of a bi-centennial statement using California as a microcosm of the whole United States, or the whole world, if you will, and to try to wake people up …'

37. The title also refers to the name given by American soldiers to Camp Nama in Baghdad. After the invasion of Iraq in 2003, the camp was taken over by Special Operations forces. On 19 March 2006 *The New York Times* reported that a unit known as Task Force 6-26 used the facility to torture and abuse prisoners. Some of the torture took place in 'The Black Room'. Prisoners were also detained in 6 x 8 foot cubicles in a cellblock named 'Hotel California'.

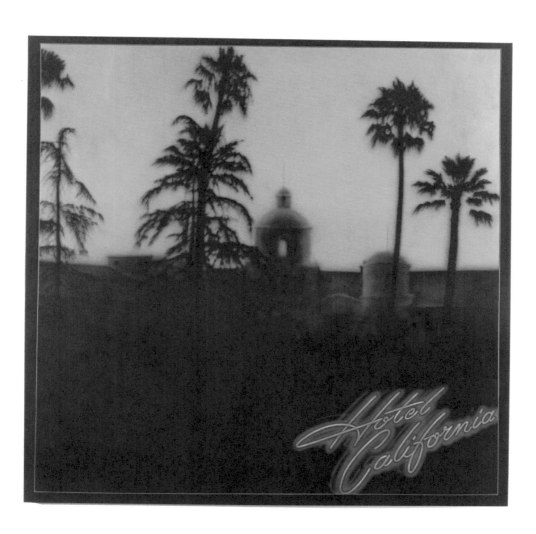

REPLICA OF A LOST ORIGINAL

2007
Digital lithography, inkjet, ballpoint, and fineliner on folded letter papers
Four parts, each part 28 x 21.6 cm

Replica of a Lost Original consists of a series of recreations –
or more accurately re-imaginings – of actual letters sent to
Ted Kaczynski, better known as the Unabomber (see cat.7),
whilst he serves a life sentence at the Federal Supermax
prison in Colorado. Each of the letters is from either a news-
paper or a TV producer/journalist requesting an interview
with Kaczynski, where he would be able to relate and explain
his crimes. Each of the writers attempts to forge a personal
link with Kaczynski in the vain hope that he will agree to be
interviewed. Kaczynski has received many of these letters
and has, as yet, refused to agree to an interview. The letters
are currently held in the archives of the University of Michigan,
and have appeared on the internet in a variety of poorly
copied files.

The work attempts to return the letters as closely as
possible to their original state through significant guesswork.
Ink colour, paper stock, and letterhead have all been spec-
ulatively re-imagined. This process is reflected in the title
which also references Kaczynski's dream of an America
returned to its roots.

ABC Television Network

GOOD MORNING AMERICA

Theodore Kaczynsky
04475-046 D Unit
United States Penitentiary
Administrative Maximum
P.O. Box 8500
Florence, CO 81226

25 August 1999

Dear Mr. Kaczynsky,

I'm going to be completely honest with you in the hopes we can start a dialogue that will eventually lead to an on-camera interview for ABC-News' *Good Morning America*.

In the time you've been incarcerated, I've sensed no diminishment of public interest in you and your philosophy/motive. I know your memoirs will be published next month and perhaps that will help people understand you better, but I feel strongly that the only way to truly understand someone is to see their eyes, hear their voice their inflections, their passion – not just read their opinions and explanations.

I know I represent a form of technology abhorrent to you, but I also know from reading excerpts from your journal (released by the government - so I wonder if they're accurate representations??) and descriptions of the intricately made explosive devices that you have a talent for using anything at hand for your purposes. I hope you decide that it's in your better interests to explain yourself to the nation....the world...by using me; to interview you and engage you in a philosophical discussion on my network's news program. I believe I'm uniquely equipped for such a task because of my varied background and education. I was born not far from where you now live, and have a cabin in the woods west of Colorado Springs that has no electricity or running water. I've been a journalist most of my life, but also a wildlife film maker and writer. I'm as intrigued by your comments on the morality of your actions as I am by your strong feelings about the environmental ravages of technology.

I have to say I can't reconcile what you've done to your fellow humans, people you didn't even know, with your obvious concerns for the sake of the planet, and by extension, its human residents. I, and a lot of people, want to know how the better angels of your nature can justify the violence your convictions required. I believe the time is right to explore those topics and your other interests.

In closing; your insistence during your arrest and hearings that you were of sound mind is something that can only be reinforced through a television interview, not your writings. People need to see you, hear you, as you talk about these things. Only then can they get a sense of your rational thought process; the logic or lack thereof.

Sincerely,

Don Dahler, National Correspondent
ABC-News, Good Morning America

147 Columbus Avenue, New York, NY 10023-6290 (212) 456-5900

CBS 2

KCBS-TV
6121 SUNSET BOULEVARD
LOS ANGELES, CA 90028
(323) 460-3000

August 15, 2001

Theodore Kaczynski
Federal Register Number 04475-046
United States Penitentiary--Administrative Maximum Facility
P. O. Box 8500
Florence, CO 81226

Dear Mr. Kaczynski:

I wrote you a few months ago. I'm the Investigative Journalist who graduated from Evergreen Park high School back in 1980.

As my first writing I asked for an interview with you. And the purpose of this letter is to again request an interview.

I've been following your case since I begun in this business, some 16 years ago. I didn't know of your involvement, of course, until your arrest. Needless to say I was floored when I learned we went to the same High School.

Here's my pitch:
One half hour on our Special Assignment TV show which airs just prior to "60 Minutes". No rules, but I do get to ask the questions. You can make your points as clearly as you wish. And we won't edit for content, only profanity (if you or I happen to use any).

I'm sure you've had offers from the "biggies". I can assure you some of us bigger local guys are every bit as good ...and 100% nicer, that the folks who would only use you to make them look bigger.

Hope you will consider.

Sincerely,

Dave Griffin
Investigative report/anchor
KCBS-TV
EPHS 1980 w/honors

NEW YORK POST

1211 Avenue of the Americas, New York, NY 10036-8790

October 3, 2001

Mr. Theodore Kaczynski
P.O. Box 8500
Florence, Colorado 81226

Dear Mr. Kaczynski;

I'm not Katie Couric, Barbara Walters, Larry King or any other famous journalist asking for an interview. I'm just a hard-working guy who monitors the news overnight for the New York Post. I also write screenplays.

While the media elite is focused on the most recent terrorist attacks and will be for some time, I would like to talk to you about these events as well as your own case for a story.

I would be happy to visit you. You can call me collect at (212) 269-4004 or write me at:

Jamie Schram
P.O. Box 20013
New York, NY 10129

Sincerely,

Jamie Schram

Jamie Schram

A NEWS CORPORATION COMPANY

THE WALL STREET JOURNAL.

One South Wacker Drive
Chicago, Il. 60606

DOWJONES

Theodore Kaczynski
04475-046
Federal Penitentiary at Florence
Florence, Colo., 81226

Nov. 2, 2001

Dear Mr. Kaczynski,

In recent weeks, I have found myself wondering about your perspective on these troubling times. Americans have come under attack in a variety of new and troubling ways. The source of the attacks remains largely unknown, and the search for the attackers seems to be proceeding with great difficulty.

Have federal agents consulted you as part of their investigations? If they were to do so, what would you tell them? Do you have any idea what sorts of people might be mailing anthrax? What might their motivation be? What steps might be taken to identify or catch them? Why do the federal investigators appear to be making so little progress?

It seems to me that the mail provides an effective method for disseminating terror. Whether or not it serves as an effective tool for violence is a subject of some debate. But I find myself wondering why these terrorists—if they possess the skill to manufacture high-grade anthrax and the wherewithal to commandeer airplanes—would settle for so crude a delivery system. Is it more important to them to spread fear than it is to spread violence?

Answers are difficult to come by amidst so much confusion. I would very much appreciate learning your thoughts on these matters.

Sincerely,

Jonathan Eig
The Wall Street Journal

ABC Television Network

Theodore Kaczynsky 25 August 1999
04475-046 D Unit
United States Penitentiary
Administrative Maximum
P.O. Box 8500
Florence, CO 81226

Dear Mr. Kaczynsky,

I'm going to be completely honest with you in the hopes we can start a dialogue that will eventually lead to
an on-camera interview for ABC-News' *Good Morning America.*

In the time you've been incarcerated, I've sensed no diminishment of public interest in you and your
philosophy/motive. I know your memoirs will be published next month and perhaps that will help people
understand you better, but I feel strongly that the only way to truly understand someone is to see their eyes,
hear their voice their inflections, their passion – not just read their opinions and explanations.

I know I represent a form of technology abhorrent to you, but I also know from reading excerpts from your
journal (released by the government - so I wonder if they're accurate representations??) and descriptions
of the intricately made explosive devices that you have a talent for using anything at hand for your
purposes. I hope you decide that it's in your better interests to explain yourself to the nation...the
world...by using me; to interview you and engage you in a philosophical discussion on my network's
news program. I believe I'm uniquely equipped for such a task because of my varied background and
education. I was born not far from where you now live, and have a cabin in the woods west of Colorado
Springs that has no electricity or running water. I've been a journalist most of my life, but also a wildlife
film maker and writer. I'm as intrigued by your comments on the morality of your actions as I am by your
strong feelings about the environmental ravages of technology.

I have to say I can't reconcile what you've done to your fellow humans, people you didn't even know, with
your obvious concerns for the sake of the planet, and by extension, its human residents. I, and a lot of
people, want to know how the better angels of your nature can justify the violence your convictions
required. I believe the time is right to explore those topics and your other interests.

In closing; your insistence during your arrest and hearings that you were of sound mind is something that
can only be reinforced through a television interview, not your writings. People need to see you, hear you,
as you talk about these things. Only then can they get a sense of your rational thought process; the logic or
lack thereof.

Sincerely,

Don Dahler, National Correspondent
ABC-News, Good Morning America

1221 Avenue of the Americas, New York, NY 10036-8790

October 3, 2001

Mr. Theodore Kaczynski
P O. Box 8500
Florence, Colorado 81226

Dear Mr. Kaczynski;

 I'm not Katie Couric, Barbara Walters, Larry King or
any other famous journalist asking for an interview. I'm
just a hard-working guy who monitors the news overnight for
the New York Post. I also write screenplays.
 While the media elite is focused on the most recent
terrorist attacks and will be for some time, I would like
to talk to you about these events as well as your own case
for a story.
 I would be happy to visit you. You can call me collect
at (212) 268-4004 or write me at:

 Jamie Schram
 P.O. Box 20013
 New York, NY 10129

Sincerely,

Jamie Schram

Jamie Schram

A NEWS CORPORATION COMPANY

DESTINY MANIFEST

2007
Inkjet prints on archival matte paper, entomology pins, United States map
190 x 130 cm

The second map work in the exhibition focuses exclusively on the United States.[38] Pinned to the location of their birthplace, the names and ambitions of each of the 600 or so *Playboy* Playmates that have appeared in the magazine since 1953 (when *Playboy* was founded) are indexed.[39] *Destiny Manifest* seeks on the one hand to reveal the proliferation of Playmates from one city or another whilst also revealing a historical overview of what was considered an appropriate ambition for a woman appearing in *Playboy* to have at a given time. The work also subverts the inherent visuality of the *Playboy* pictorial by reducing the models to a set of statistics. This in turn also furthers the notion of dreams unrealised.

38. 'Manifest Destiny' is a phrase originating in the mid-nineteenth century that expressed the belief that the United States was destined to expand from the Atlantic seaboard to the Pacific Ocean; it has also been used to advocate or justify other territorial acquisitions.

39. The 'Playmate of the Month' pictorial includes nude photographs and a centerfold poster, as well as a short biography and the 'Playmate Data Sheet', which lists birth date, measurements, turn-ons, and turn-offs and ambitions, amongst other things.

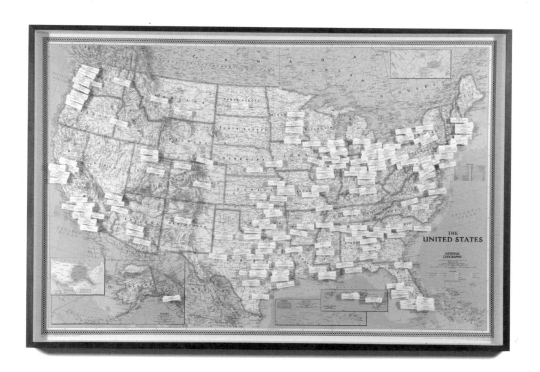

Wells
Carson
40
Weskan
Sharon Springs
Gove
70
WaKeeney
Lucas
Ellis
Wilson Lake
Hays
Victoria
Russel
Cedar Bluff Res.
Smoky Hill
385
Res.
Tribune
Leoti
Healy
Scott
City
Dighton
96
283
La Crosse
Ness City
Hoisington
C
183
Great Bend
Larned
St
Holly
mar Granada
Lake
McKinney
50
83
Garden City
Jetmore
FORT LARNED
N.H.S.
156
Arkansas
H.S.
Syracuse
Lakin
50
Cimarron
Kinsley
Lewis
27
Two
Buttes
Johnson
83
Ulysses Montezuma
Dodge City
50
56
I'm worki
160
Satanta
56
283
Greensburg
Bucklin
54
P
Haviland
ush
G
Cimarron
Hugoton
Sublette
Fowler
Minneola
183
+2265
Medicine
Lodge
mpo
Plains
54
Meade
Red Hills
Coldwater
Elkhart
Liberal
Ashland
Protection
281
56
Tyrone
64
Forgan
283
183
Englewood
Salt Fork
Keyes
64
Hooker
64
Gate
Buffalo
Arkansas
Freedom
64
Alva
Beaver
S.
Beaver
Laverne
Waynoka
Carmen
Cherol
Goodwell
Guymon
3
Fort Supply
Cimarr
287
Texhoma
Woodward
Mooreland
1582+
water Creek
Booker
Perryton
Darrouzett
Follett
Wolf Creek
Shattuck
183
281
Car
ratford
15
Gruver
15
Spearman
Lipscomb
83
Higgins
60
Vici
Seiling
N. Canadia
54
hart
Cactus
Sunray
287
207
Canadian
Arnett
Camargo
Taloga
Car
Dumas
152
Stinnett
Phillips
Miami
60
Washita
Leedey
283
183
281
85
IBATES FLINT
IES NAT. MON.
Fritch
Borger
Pampa
Mobeetie
Cheyenne
Hammon
Weatherford
Thomas
33
Hydro
Gea
osa
Meredith
87
LAKE MEREDITH
N.R.A.
152
White Deer
North Fork
Wheeler
Elk City
Clinton
Cordell
Hin
Bi
Panhandle
Groom
40
Red
Sayre
40
Erick
Cobb Res.
O
K
marillo
Duro C
Claude
McLean
Shamrock
283
Sentinel
Carnegie
Ana
60
Canyon
287
Clarendon
83
Mangum
Granite
Hobart
Apach
a Cr.
Mulberry
Prairie Dog
Hedley
Wellington
2479+
Wichita Mts.
Happy
Memphis
Dodson
Dimmitt
Tulia
Silverton
Estelline
Hollis
Al
Gale O
Hart
Turkey
Eldorado
Childress
Miss Augus

Crystal Smith
Miss September 1971
I'd like to be a professional dancer, and to a...
State University.

Susie Owens
Miss March 1988
To expand my business in every directio...
fitness expert and trainer to promote w...

e Woodson
April 1973
come the best in my two careers -
ing and acting.

Vicki Lynn Lasseter
Miss February 1981
To become a successful model, appear on "The Tonight
Show" and act in TV soaps and commercials.

Carrie Westcott
Miss September 1993
I want a career, family and happiness. The goat climbs
to the top of the mountain.

Candy Loving
Miss January 1979
To take the days one at a time and...

Laura Misch
Miss February 1975
Freelance writing and photography.

Colleen Marie
Miss August 2003
s a model for the next 3-5 yrs, then focus on
inary career and becoming a great doctor.

Sharon Clark
Miss August 1970
I plan to teach English at some small university.

WHITE THIEVERY AND AN EMOTIONAL SHAM

2007
Record player playing original vinyl pressing of Tim Buckley's *Starsailor*,
suspended cement block, rope, motor, two Marshall half-stacks, four
microphones and microphone stands, mixer, and cabling with plinth
150 x 200 x 400 cm

This work features the only actual example of music that can
be heard in the exhibition. It crosses the formats of a Bas Jan
Ader work (*Light Vulnerable Objects Threatened by Eight
Cement Bricks* 1970) and a Paul Kos performance sculpture
(*The Sound of Ice Melting* 1970) with the spectre of Tim
Buckley (1947–75). Buckley's career epitomises the
progression from idealism to disillusion played out within
A Dream Deferred.[40]

While his work has since been critically reappraised, for
Shovlin's generation Tim Buckley is better known as the
father of Jeff Buckley, who achieved cult success in the 1990s.
Both Buckleys, and Ader as well, died tragically early.[41] Ader
and Buckley junior both drowned in water, which is evoked
by the choice of *Starsailor* (1970) which plays here. This
selection also references Ader's most famous project.[42]

In the installation the playing record is amplified through
microphones rather than through cabled speakers, as would
normally happen. The effect of this is to include the actual
context in which the music is played, such as the sounds of
spectators around the installation. A cement brick suspen-
ded by rope threatens the record playing and evokes the
cultural and financial fragility of music (and other creative
endeavours), something Tim Buckley was all too aware of.
Buckley never achieved commercial success and *Starsailor*
– the album now widely recognised as his masterpiece –
was universally derided on release.[43] The title is a reference
to Tim Buckley's oft-quoted description of the rock that
dominated the American music scene in the early 1970s,
music that, in the context of the show, surrounds him.

40. Buckley's early work – on albums such as *Tim Buckley* (1966) and *Goodbye and Hello* (1967) – was rooted in the singer-songwriter protest movement in Greenwich Village in the mid 1960s and his later work is characteristic of the West Coast rock scene; his shift from one to the other resulting in a transition from critical acclaim and modest commercial success to critical derision and commercial failure

41. Further correspondences are suggested by the fact that not only are Tim Buckley and Bas Jan Ader

strikingly similar looks-wise, but both died in 1975.

42. Ader's ambitious project, *In Search of the Miraculous* (1975) was intended as a triptych of actions. The second part involved a solo crossing of the Atlantic. On 9 June 1975 Ader set sail from Cape Cod in his 13ft cabin yacht, intending to sail to Amsterdam, where he was to make an exhibition about the journey at the Groninger Museum. He never arrived.

43. Many believe that the decline in record sales that corresponded with

Buckley's move away from simple folk to more experimental fare on albums such as *Happy Sad* (1968), *Lorca* (1969) and *Starsailor* (1970), meant that Buckley later sold out in making more commercially orientated music for his final few albums before his accidental drug-overdose in 1975.

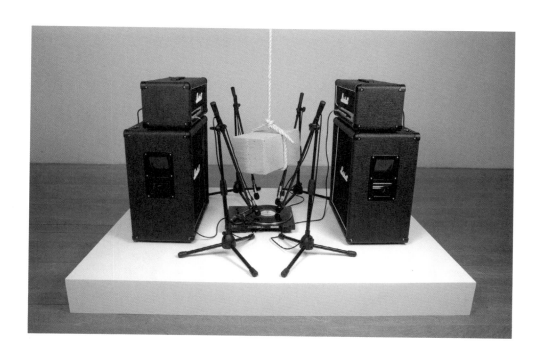

IS IT BETTER TO BURN OUT THAN IT IS TO RUST?

2007
Acrylic signage and fixings
15 x 240 cm

Is it better to burn out than it is to rust? co-opts the title of a
video compilation by Nirvana, *Live! Tonight! Sold Out!!,* which
was the first band release after Kurt Cobain's suicide in 1994.[44]
The appropriated text is manufactured to appear as if it was
taken from a music venue, but also recalls Jack Pierson's
signage works that attempt to 'document the disaster in-
herent in the search for glamour'.[45]

To Shovlin, Cobain represents a flipside to the slick com-
merciality of the Eagles, America and other 1970s bands
from the family record collection. The work attempts to
ground the musical concept of 'selling out' in the context
of Cobain's suicide.[46]

The title refers to Cobain's use of a lyric by Neil Young from
the song 'Hey, Hey, My, My' – 'It's better to burn out than to
fade away' – in his suicide note.[47] Shovlin uses a lyrical
variation that Young offers on the seminal live album, *Live
Rust* (1979).

44. Kurt Cobain (1967–1994) was the
lead singer and songwriter of
Nirvana, the band he founded in
Seattle in 1987. After the huge inter-
national success of 'Smells Like Teen
Spirit' in 1991 Cobain became a rel-
uctant spokesman for Generation X.
He was found dead of a self-inflicted
shotgun wound to the head in his
home in 1994.

45. Richard D. Marshall, *Jack Pierson
Desire/Despair: A Retrospective:
Selected Works 1985–2005,* Rizzoli,
2006 p.7.

46. *'Nirvana were a band – perhaps
the first band – I connected with on
more than a musical level, believing
their rhetoric about and (supposed)
rejection of the perils of commercially
orientated music. This was shot to
pieces by Cobain's suicide (literally
one could say), which was almost
a kind of awakening for me.'* Artist's
notes for *A Dream Deferred.*

47. Two variations on a theme,
acoustic and electric, 'Hey Hey, My
My (Into the Black)' and 'My My, Hey
Hey (Out of the Blue)', bookend
Young's 1979 album *Rust Never
Sleeps.* They articulate Young's fear
of obsolescence and growing aware-
ness of – and appreciation of – the
iconoclasm of punk.

LIVE! TONIGHT! SOLD OUT!!

SOLD

OUT!!!

DYSCRASIA

2007
Archival inkjet print on Hahnemühle photo rag paper, Crayola's *America's Favorite Colors* crayons
100 x 100 cm

Dyscrasia presents a mandala-like spiralling chart, recording the various manners by which philosophers, alchemists, scientists, psychologists, and Crayola have accorded properties and traits to personality types by an historical relationship to the four humours of the body.[48] Although the four humour theory was medically disproved almost 500 years ago it still thrives as a basis for personality analysis in modern psychiatry. The chart documents the historical motion of these various theories, originating in ancient Greece, before moving outwards across Europe and then making the transatlantic jump during the Second World War. The chart is brought up to date using Crayola's millennial survey of 'America's Favorite Colors', listing the personality types of people who choose specific colours, again reiterating the connection to the basic four humour theory.

Dyscrasia also links to the wax limbs of *Alternative Monument to Mexico City, 1968* (cat.13), which are cast in part from 'America's Favorite Colors.'

48. *Dyscrasia* (from Greek 'Dyskrasia', meaning bad mixture), in Ancient Greek medicine, is the imbalance of the four humours, and was believed to be the direct cause of all disease.

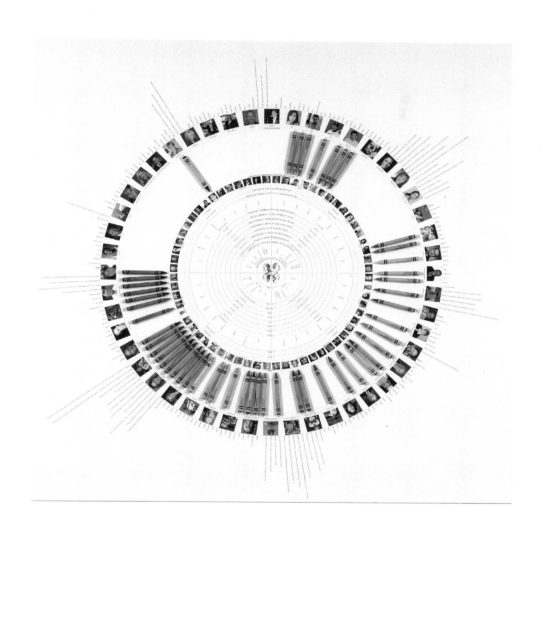

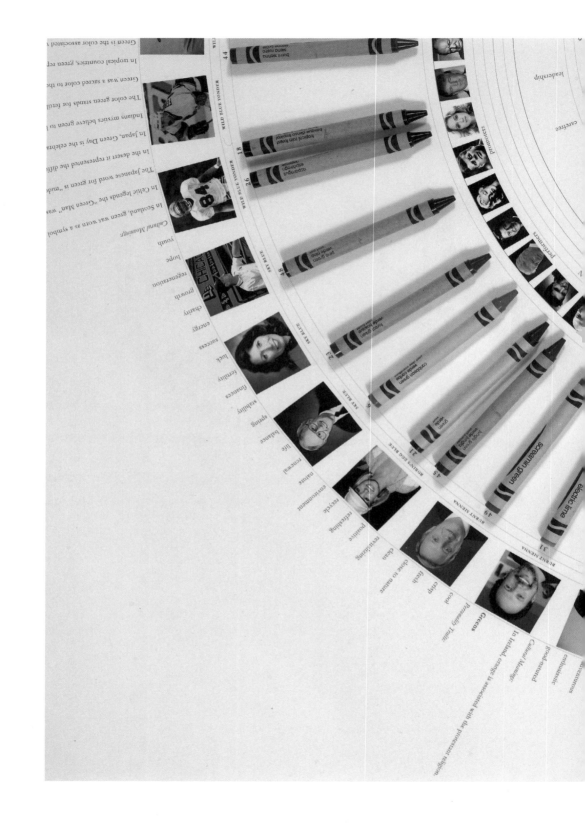

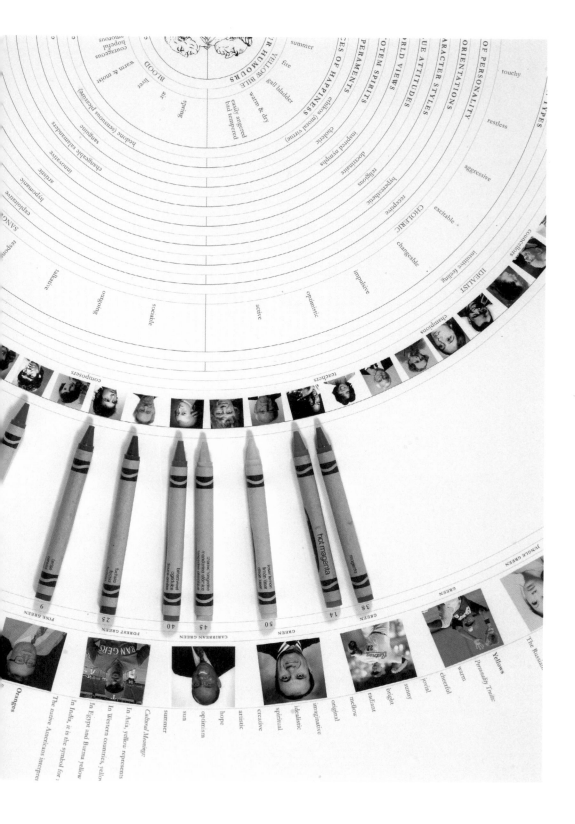

MONTAGE OF A DREAM DEFERRED

2007
Copy of *Life* Magazine, August 29, 1969, with plinth, Perspex top
Magazine 34.5 x 52.5 cm, overall 100 x 82 x 110 cm

The final work in the exhibition takes a copy of *Life* magazine and dissects it from the spine outwards. As a result it reveals a double-page spread juxtaposing a story covering the Woodstock festival with an account of Sharon Tate's murder by members of Charles Manson's notorious 'Family' (although at the time of publication, her murderers were unknown).[49] Tate's husband, the film director Roman Polanski, is pictured by the front door of their house, the word 'PIG' scrawled on the door in her blood. These two events, which happened just days apart in August 1969, embody the contradictions facing America at the end of the 1960s more than any others.

49. On 8 August 1969 Sharon Tate, who was eight months pregnant, and four others were killed at the LA mansion she shared with Roman Polanski. The following evening members of the 'Family' also killed Leno and Rosemary LaBianca. In 1971 Charles Manson was convicted of conspiracy to commit the Tate-LaBianca murders, which members of the 'Family' commune carried out at his instruction. Though there was no evidence Manson personally killed any of the victims, he was also found guilty of the murders themselves, through the joint-responsibility rule

of conspiracy. At his most-recent parole hearing, in May 2007, Manson was denied parole for the 11th time. He did not attend because he considers himself a 'political prisoner.'

The Woodstock free festival ran from 15–18 August 1969. Ravi Shanker, The Who, Crosby, Stills, Nash & Young, Sly & The Family Stone, The Grateful Dead, Jefferson Airplane, Jimi Hendrix and many others performed. The event has been idealized in the American popular culture as the culmination of the hippie movement: a free festival where nearly 500,000 'flower children' came together to celebrate.

Roman Polanski comes home to the scene of the Sharon Tate murders

A Tragic Trip to the House on

After a harrowing tour of the house, Theater Roman Polanski sits on the bloodied porch, beside door where the killer scrawled "Pig" in blood

In a pinch, a sweater buttoned will do for two

Workers in the Hog Farm-free kitchen prepare food, chop vegetables for salad

Making do barefoot

At Bethel the festival had the look of a massive, poorly supervised, three-day summer camp for city kids. "Wow" said one fellow looking across a field, "it sure!" Festival permits had casually spread. "Look your own food, camp out" without offering specifics, two East Village artists were spotted trying to warm soup in a beer can suspended by string over a newspaper fire. Doctors reported red feet were the major medical problem—kids used to strolling barefoot on downtown-area city streets were undone by glass in the grass. Others happily plucked their own ripe feet. Disaster was always just around the corner, but it never arrived, partly because of the strong spirit of helping and sharing. "Some of the water pipes have been broken and the breaks are hard to find," announced officials at one point. "If you have accidentally stepped on a pipe and broken it, left someone wearing a Woodstock shirt." People told, the pipes were fixed, the crisis averted.

For a while, washing made sense. Then the mud got too deep

With mud without clothes, kids gather in throng in a pond

DREAMS DEFERRED

RECENT PROJECTS BY JAMIE SHOVLIN

Ben Tufnell

'Those who expected the illusion of their own inherent goodness to last forever are still freaked. Others, who pay less attention to the rhetoric of a cultural revolution, say they had a good time. Putting it all together reads like America's pulse *now*. After all, we not only make beautiful music, love and beadwork; we pay our pigs to exterminate Black Panthers, we fry Vietnamese in their own homes and we elect Spiro Agnew to govern our lives.

It was over. No explanation was needed, only a feeble plea for someone in America to clean it up. The stirrings of a young but growing movement to salvage our environment. The job of cleaning up Altamont, as America, is still up for grabs. America wallows in the hope that someone, somewhere, can set it straight. Clearly nobody is in control. Not the Angels, not the people. Not Richard Nixon or his pigs. Nobody. America is up for grabs, as she sinks slowly into Methedrine suffocation with an occasional fascist kick to make her groan with satisfaction.'

George Paul Csicsery, 'Altamont, California', *The New York Times,* 8 December 1969

On 6 December 1969, just a few months after almost 500,000 so-called Flower Children had gathered in the mythical mud at Woodstock, The Rolling Stones headlined a free concert at the disused Altamont Speedway in Northern California. As the Stones played *Under My Thumb* a young Black American called Meredith Hunter was stabbed and kicked to death by Hell's Angels within view of the stage.

Altamont is often positioned as the end of 'The Sixties'. In popular myth it is the moment that a certain hopeful idealism died, or at least received a mortal wounding. For in truth The Sixties – and all that they represented – didn't expire there and then. In the US the ideals of liberal permissiveness, free love, Civil Rights and Freak Power had been in retreat since at least the year before, when Martin Luther King and JFK were assassinated and there was a 'police riot' at the Democratic Convention in Chicago. 1968 was the year the tide can be said to have turned.[I] It was the year of *Night of the Living Dead* and *Planet of the Apes,* films that depicted societies in crisis. As Peter Fonda's character Wyatt put it in *Easy Rider* (which was filmed in 1968, but not released until the following year), summing up a widespread feeling of disillusion: 'You know Billy, we blew it.'

After Altamont and the dawning of the 1970s the ideals of The Sixties limped on. While some might say that they were finally laid to rest sometime in the mid-1980s, amidst mobile phones, shoulder pads and stadium rock, in fact the long hangover from that mythologised decade continues, and it is this that Jamie Shovlin's project, *A Dream Deferred,* explores.

Here the past is, to borrow LP Hartley's famous phrase, 'a foreign country.'[II] Shovlin portrays an English history – one formed in the suburbia of the Midlands – that is culturally saturated by a particular strain of Americana. America – and particularly the post-Sixties pop culture of the American west coast – is the tint that colours everything. Here is a hall of mirrors. Look back at 1980s suburban England – as Shovlin has done – and you find strange reflections of Woodstock and Altamont, the Sunset Strip and the American Dream. *Hotel California* still plays on the pub jukebox at closing time.

Jamie Shovlin is perhaps best known for a series of ambitious projects, including *Naomi V. Jelish* (2001–2004) and *Lustfaust: A Folk Anthology 1976–81* (2003–6), in which he constructed extensive archives, which were then revealed to be elaborate fictions.[III] The Jelish archive consists of drawings, newspaper cuttings and other ephemera relating to a 13-year old prodigy who apparently disappeared with her family in mysterious circumstances, along with notes and inventories made by John Ivesmail, a 'retired science teacher at Naomi's school [who had] unearthed a collection of the teenager's remarkable drawings' (both Naomi V Jelish and John Ivesmail are anagrams). A second archive,

I. For a useful overview and international perspective see Mark Kurlansky, *1968: The Year that Rocked the World,* London, 2004

II. LP Hartley, *The Go-Between* (1953): 'The past is a foreign country; they do things differently there.'

III. See www.naomivjelish.org.uk and www.lustfaust.com

'curated by Jamie Shovlin' and purporting to document the activities of a German 'experimental noise band' from the 1970s, *Lustfaust: A Folk Anthology 1976–1981* (2003 –2006) contained cassette covers and posters apparently made by the band's supporters, fan reminiscences, a filmed interview with one of the band members, and even short samples of Lustfaust's music. When these works were shown at Riflemaker and the Saatchi Gallery, London, Freight & Volume in New York and in *Beck's Futures* at the ICA, Shovlin was hailed as an art-world hoaxer par excellence, a reading which perhaps foregrounds the extraordinary technical facility involved in producing the work but which sidelines the seriousness of the undertaking.[IV] Such works in fact represent a profound meditation on truth and doubt, and the subjectivity of interpretation. Lustfaust's story is one of creativity, idealism and eventual conflict and failure – dreams broken and deferred – and the Jelish material evokes a tragic and disturbing narrative. Both works herald a major theme which runs through all Shovlin's recent work: loss. The loss of innocence and the failure of dreams and idealism is evoked by the unreliability of memory, the fractures that appear in any account of the past, the flawed logic inherent in any system of classification. In Shovlin's world the past is retrievable only as a form of simulacra, inherently doubtful. It is another country.

Shovlin's *Fontana Modern Masters* project (2003–2005) extended the artist's interest in exploring such ideas, investigating an absurdist premise: that intellectual achievement can be ranked or scored according to a points system. Fascinated by the ambition and appearance of Fontana's series of books, 'Modern Masters' (which proposed to examine the thinkers 'who have changed and are changing the life and thought of our age'), Shovlin constructed a system – set out in the *Fontana Colour Chart* (2003–2005) – which would allow him to 'accurately' produce the covers of the books which Fontana had announced it was to publish but which, for whatever reason, had never appeared. Thus the existing books were analysed, and the colours used in the cover designs were assigned values derived from the amount of space they occupied, the percentages being taken from the intellectual 'score' of each 'Modern Master' (a total arrived at by a series of seemingly arbitrary criteria). Working from the covers of the existing books Shovlin was therefore able to extrapolate the appearance of non-existent books about such heavyweights as Adorno and Lacan. Painted in watercolour, the archetypal medium of the amateur, the drips and runs of paint that grace these new cover designs return us to an awareness of the flawed nature of Shovlin's proposal.

For his exhibition at Tate Britain in 2006, *In Search of Perfect Harmony,* Shovlin created work which appropriated the conventions of museological display. Using drawings, collage, text, sound recordings and projections, the installation juxtaposed his mother's subjective view of the wildlife

IV. See, for example, Nigel Reynolds, 'Portrait of the Artist as a Young Hoaxer', *The Daily Telegraph,* 2 July 2004.

in her suburban garden with the scientific rigour of Charles Darwin's theory of natural selection, as set out in *The Origin of Species* (1859). These concerns were more comprehensively explored and set within a wider context of knowledge – indicated by an installation of OS 'Landranger' maps sourced on eBay – in the large-scale touring exhibition *Aggregate* (2003–2007). These exhibitions suggested that scientific enquiry and speculation present a form of flawed idealism. It purports to render the world knowable yet cannot. In the gaps between biology, anthropology and taxonomy Shovlin evokes art and poetry; Darwin's theories explain the motivation for a Sparrowhawk attack in his mother's garden, but not the metaphorical implications of such an event.

From even such a cursory examination of Shovlin's recent work it is apparent that his artistic preoccupations are wide ranging. He is interested in the tension between truth and fiction, reality and invention, history and memory. And failure is a key theme.

A Dream Deferred, advances many of these concerns. It is a subjective exploration of recent American history, politics and culture, taking as a framework his parent's record collections; the US-dominated soundtrack of his early life. A series of large-scale paintings appropriate imagery from the covers of records by Bob Seger, Hall & Oates and the Eagles but are painted using techniques associated with modern American masters

such as Ellsworth Kelly, Kenneth Noland and Frank Stella. Taking these as his starting point Shovlin has created a complex web of allusion and association, mixing family history and autobiography with references to the 1968 Mexico Olympics, *Playboy,* Woodstock, Sharon Tate and Charles Manson, Abbie Hoffman and the Unabomber, and drawing on a personal art history dominated by Robert Gober, Lawrence Weiner, Bruce Nauman, Felix Gonzalez-Torres, William Eggleston and Ed Ruscha. The soundtrack is the music of the 'denim navel-gazers and cheesecloth millionaires of the Los Angeles canyons.'[v]

The exhibition presents a narrative of hope and disillusion. Shovlin's title – which is taken from Langston Hughes' poem, *Harlem,* of 1951 – points to the ways in which the ideals of the 1960s (when his parents met) were alternately compromised by commercial imperatives, buoyed up by the music and then broken and abandoned. As Jack Nicholson's character says at another key moment in *Easy Rider,* 'It's real hard to be free when you're bought and sold in the marketplace.'

A Dream Deferred offers a distanced view of America, filtered through music, art, movies and the arbitrary structures of the internet. In doing so it also offers us a view of middle England in the 1970s, 80s and 90s. The past may be another country, but it is one in which the language, obsessions, problems and hopes – and crucially the music – are uncannily familiar.

V. Barney Hoskyns, *Hotel California: Singer-Songwriters and Cocaine Cowboys in the LA Canyons 1967–1976*, Fourth Estate, London, 2005.

JAMIE SHOVLIN
Born Leicester, 1978

EDUCATION
2001–2003
Royal College of Art, London

1998–2001
Loughborough University
School of Art & Design

1997–1998
Loughborough College of Art and Design

	SELECTED SOLO EXHIBITIONS	SELECTED GROUP EXHIBITIONS
2007	*A Dream Deferred* Haunch of Venison, London	*Black and White* IBID Projects, London *Alchemy Artists* Manchester Museum, Manchester *Elephant Cemetery* Artist's Space, New York
2006	*Aggregate* City Gallery, Leicester; ArtSway; Talbot Rice Gallery, Edinburgh; Hatton Gallery, Newcastle *Lustfaust: A Folk Anthology 1976–1981* Freight & Volume, New York *In Search of Perfect Harmony* Art Now, Tate Britain, London	*Naturalia* Unosunove, Rome *The Portrait* V22, Ashwin Street, London *Beck's Futures* ICA London, CCA Glasgow and Arnolfini, Bristol
2005	*Fontana Modern Masters* Riflemaker, London	*After the Fact* Tullie House Museum, Carlisle
2004	*For Some Other Cause* IBID Projects Vilnius, Lithuania *Naomi V. Jelish* Riflemaker, London	*Galleon and Other Stories* Saatchi Gallery, London *Artfutures* Contemporary Art Society, London *This much is certain…* Royal College of Art Galleries, London
2003		*Inside Out – Investigating Drawing* Milton Keynes Gallery *Please – Take One* '39', Mitchell St, London *New Contemporaries* Wharf Road, London and Cornerhouse, Manchester
2002	*Five Books* Hockney Gallery, Royal College of Art, London	*Artlab22: Over The Road* Imperial College, London *Spectrum ll* Heathcote Arts, Nottingham *Diversion* Arch 295, Camberwell, London

BIBLIOGRAPHY

PUBLICATIONS

Elephant Cemetery
Artist's Space, New York, 2007; Essay by Christian Rattemeyer

Naturalia: Mat Collishaw, Ellen Gallagher, Jamie Shovlin
Unosunove, Rome, 2006; Essay by James Putnam

Aggregate
City Gallery, Leicester et al., 2006; Texts by Kathy Fawcett, Peter Bonnell, Graham Giddens, Maria Newbery, Pat Fisher, Karen Chapman and Rachel Tant

Lustfaust: A Folk Anthology 1976–1981
Freight & Volume, New York and Riflemaker, London, 2006

Beck's Futures 2006
ICA London, 2006; Essay by Francesco Manacorda

Art Now: Jamie Shovlin
Tate Britain, London, 2006; Essay by Rachel Tant

After the Fact
Tullie House, Carlisle, 2005; Texts by Fiona Venables and Anthony Vidler

Fontana Modern Masters
Riflemaker, London, 2005; Texts by Martin Holman and Jamie Shovlin

Naomi V. Jelish
Riflemaker, London, 2004; Essays by Tony Godfrey and John Ivesmail

This much is certain…
Royal College of Art, London, 2004

SELECTED ARTICLES AND REVIEWS

Steven Cairns, 'Jamie Shovlin', *Map Magazine,* Issue 9, Spring 2007
David Velasco, 'Elephant Cemetery', *Artforum,* March 2007
Dan Smith, 'Unnatural Histories', *Art Monthly,* No. 304, March 2007
James Mottram, 'Flying in the Face of Facts', *The Herald,* 31 January 2007
Sarah Unwin-Jones, 'Jamie Shovlin: Aggregate', *Metro,* 26 January 2007
Martin Lenon, 'Jamie Shovlin: Aggregate', *Edinburgh Evening News,* 23 January 2007
Duncan MacMillan, 'Arm against the Sleep of Reason', *The Scotsman,* 23 January 2007
Iain Gale, 'Origin of the Human Magpie', *Scotland on Sunday,* 21 January 2007
Jack Mottram, 'Jamie Shovlin: Aggregate', *The Herald,* 20 January 2007
Susan Mansfield, 'The Tricks of a Con Artist', *The Scotsman,* 20 January 2007
Rosie Lesso, 'Aggregate, Jamie Shovlin', *The List,* Issue 567, 18 January 2007
Rachel Campbell-Johnston, 'The Times Breakthrough Award Nominees', *The Times,*
 12 January 2007

Alex O'Connell, 'The names to bank on', *The Times 2,* 18 December 2006

Sean Ashton, 'Truant Creativity in the "Work" of Mike Harte … and Brendan Fahy',
 V22 Collection, Ashwin Street, 2006

Michael Williams, 'Jamie Shovlin, Freight + Volume', *Artforum,* October 2006

Jamie Shovlin, 'Tape Delay', *Plan B,* Issue 13, August 2006

Mark Gubb, 'Jamie Shovlin: Aggregate', *A–N Magazine,* August 2006

Roberta Smith, 'Art in Review: Lustfaust…', *The New York Times,* 21 July 2006

Martin Holman, 'Who Needs Actions When You Got Words?', *Miser & Now,* Issue 8, July 2006

Fred Dellar, 'Surf's Up!', *Mojo,* July 2006

Robert Clark, 'Aggregate', *Guardian Guide,* 3 June 2006

Amy Bell, 'Aggregate', *Metro,* 1 June 2006

Martin Coomer, 'Beck's Futures', *Modern Painters,* June 2006

Alice Jones, 'It's only mock and roll…' , *The Independent,* 1 May 2006

Charles Darwent, 'Where did it all go right?', *The Independent on Sunday,* 9 April 2006

Jessica Lack, 'Beck's Futures', *Guardian Guide,* 8 April 2006

Adrian Searle, 'Foot fetish', *The Guardian,* 4 April 2006

Serena Davies, 'Beck's finds its fizz again', *The Daily Telegraph,* 4 April 2006

Laura Cumming, 'Sip it and see', *The Observer,* 2 April 2006

Waldemar Januszczak, 'In a world full of dull awards…', *The Sunday Times,* 2 April 2006

Nick Hackworth, 'The Future looks … intensely ugly', *Evening Standard,* 29 March 2006

Rachel Campbell Johnston, 'The whys are getting easier to answer…', *The Times,*
 29 March 2006

Sarah Kent, 'Jamie Shovlin', *Time Out,* No. 1855, 8 March 2006

'Critic's Choice', *Time Out,* No. 1854, 1 March 2006

'Op Art', *The Guardian,* 25 February 2006

Grayson Perry, 'It's original but is it any good?', *The Times 2,* 22 February 2006

'Document', *Another Magazine,* Issue 10, February 2006

Charlotte Higgins, 'In search of the artists young artists admire', *The Guardian,*
 12 January 2006

Catherine Morland, 'Jamie Shovlin', *Contemporary,* No. 76, September 2005

Paul Taylor , 'After The Fact', *A–N Magazine,* July 2005

Jessica Lack, 'Picks of the Week', *The Guardian G2,* 25 April 2005

Susannah Price, 'Pants on Fire: The World's Biggest Lies', *Sunday Times Magazine,*
 21 August 2004

Richard Dorment, 'The Fakes that Reveal Reality', *The Daily Telegraph,* 14 July 2004

Fisun Guner, 'Galleon & Other Stories', *Metro,* 9 July 2004

Nick Hackworth, 'Still Making Waves', *Evening Standard,* 6 July 2004

Louise Jury, 'Just a side order of controversy…', *The Independent,* 3 July 2004

Nigel Reynolds, 'Portrait of the Artist as a Young Hoaxer', *The Daily Telegraph,* 2 July 2004

Sally O'Reilly, 'Jamie Shovlin', *Time Out,* No. 1764, 9–16 June 2004

Chris McCormack, 'This Much is Certain', *Contemporary,* No. 63, June 2004

Richard Dyer, 'News', *Contemporary,* No. 62, May 2004

Sally O'Reilly, 'This much is certain', *Time Out,* No. 1753, 24–31 March 2004

Charles Darwent, 'Hung, drawn and totally pointless', *Independent on Sunday,*
 21 December 2003

Martin Vincent, 'Bloomberg New Contemporaries', *Art Monthly,* September 2003

Published by Haunch of Venison on the
occasion of the exhibition *Jamie Shovlin:
A Dream Deferred* at Haunch of Venison,
London
6 July – 18 August 2007

Haunch of Venison

LONDON
6 Haunch of Venison Yard
off Brook Street
London W1K 5ES
United Kingdom
T +44 (0)20 7495 5050
F +44 (0)20 7495 4050
london@haunchofvenison.com

ZÜRICH
Lessingstrasse 5
8002 Zürich
Switzerland
T +41 (0) 43 422 8888
F +41 (0) 43 422 8889
zurich@haunchofvenison.com

www.haunchofvenison.com

All works © Jamie Shovlin
Publication © Haunch of Venison 2007

Edition of 1500
ISBN: 978-1-905620-17-3

Design: www.williamhall.co.uk
Print: Lecturis
Photography: Matthew Hollow

Main text set in 'Cheltenham' (US, 1896),
designed by Bertram Grosvenor Goodhue,
a distinguished American architect.
Chelteham is used as a headline font by
The New York Times.

Headline text set in 'Franklin Gothic'
(US, 1903), designed by Morris Guller Benton
and used by Lawrence Weiner in its Bold
Condensed weight.

The artist would like to thank: Sigrid
Holmwood, 360 Models, BPD Phototech, Alli
Beddoes, Michael Bracewell, Kieran Brown,
Adrian Chesterman, Niall and Nils at
Dandelion & Burdock, Rich Walker at DNR
Colour Printing, Matt, Nick and Zeyad at
Haunch of Venison, Matthew Hollow,
William and Nicholas at William Hall, Ken at
Imprint, James Ireland, Kelly, Matt and Paul
at John Jones, LMF, Becky Sinden, Claudia
Stockhausen, Ben Tufnell, Andrew Turnbull,
Claire Walsh, Matt Watkins, and Murray Ward.

Special thanks go to Valerie Hayes and Denis
Shovlin, without whom this project could
never have happened.